VERMONT GATHERING PLACES

WRITTEN AND PHOTOGRAPHED BY

Peter Miller

Silver
Print
Press

COLBYVILLE
VERMONT

This book is dedicated to all who support and maintain
Vermont's gathering places and the events that take place there.

This book has been generously supported by

THE PRESERVATION TRUST OF VERMONT
on the occasion of their 25th anniversary

VERMONT ARTS COUNCIL

SOVERNET

Copyright 2005 by Peter Miller
All Rights Reserved. No part of this publication may be
reproduced without written permission from the publisher.

Published by Silver Print Press
20 Crossroad
Colbyville, Vermont 05676
Email: info@silverprintpress.com
Website: www.silverprintpress.com

OTHER BOOKS BY PETER MILLER
Vermont People
Vermont Farm Women
People of the Great Plains
The First Time I Saw Paris
The 30,000 Mile Ski Race
Peter Miller's Ski Almanac
The Photographer's Almanac (coauthor)

Edited by Kristen Lewis
Design by Peter Holm, Sterling Hill Productions
Printed in Canada by Friesens

First Edition; September 2005

ISBN: 0-9749890-4-5

PUBLISHER'S CATALOGING-IN-PUBLICATION DATA
Miller, Peter, 1934—
Vermont Gathering Places
160 pages, 185 photographs 22 cm x 27 cm.
Documentary photos and text of Vermont gathering places
1. Community Life — Vermont
2. Historic Buildings — Vermont
974.3
Library of Congress Cataloging Number: 2005906749

ACKNOWLEDGMENTS

Vermont Gathering Places exists because of the Preservation Trust of Vermont. Henry Jordan, the Trust's president, conceived the idea, and he and his wife Barrie funded its publication. Henry is a good friend and a wonderful person to work with because he is positive and thinks clearer than I.

The Trust's executive director, Paul Bruhn, acted as editorial director. My thanks to him for allowing the book to find its own life.

Kristen Lewis developed the contacts, scheduled my visits, researched and checked the facts, and coordinated the production of the book. She also bounced around ideas for the stories, and so helped shape the book. Tight deadlines allowed her only a few days off to give birth to her son Aidan—nine and a half pounds at birth and doing fine.

Like a few of my previous books, *Vermont Gathering Places* was designed and produced by Peter Holm of Sterling Hill Productions. He has a very good eye for the combination of photos, text, and space and because of this several of our books have won national awards.

There are many people who contributed to the individual stories or supplied information that led to a story's inclusion in this book. Some allowed me to photograph and interview them. They are too numerous to mention but each, when looking at a story they contributed to, or that pictures them, can say "Hey, that's my story!" They helped make this book what it is and I am grateful for the collaboration.

In 2003, The Vermont Arts Council gave me a grant to photograph country stores in Vermont. Its executive director, Alexander Aldrich, and his staff have graciously allowed me to include the images from their grant in these pages. I think the section on country stores is one of the strongest in the book and I appreciate the help of the Vermont Arts Council.

PETER MILLER
September 2005
Colbyville, Vermont

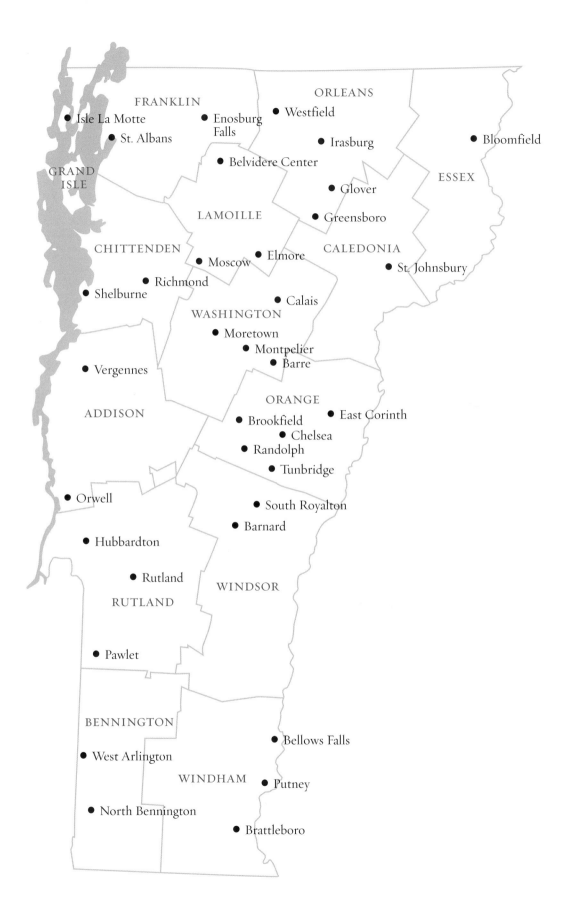

Contents

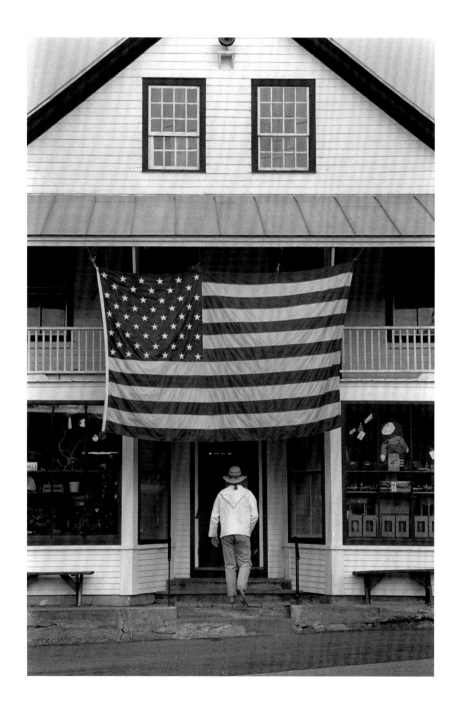

*V*ermont *Gathering Places* was published to celebrate the twenty-fifth anniversary of the Preservation Trust of Vermont. The photographs and stories speak of the connections between our friends and neighbors, residents who live in our communities and the folks who come to visit the wonderful world that is Vermont. It is also about how our communities work. Peter Miller illustrates poignantly Vermont's wealth of special and eclectic gathering places.

Vermont is a unique and special place in this vast world of ours. In 2005, the state of Vermont, population 650,000, was recognized by the prestigious National Geographic Society's *Traveler* magazine on its list of world-class destinations. Over two hundred experts evaluated 115 of the world's best-known places, using on criteria that measured cultural, environmental and aesthetic integrity. Vermont was tied for sixth place, alongside Kruger National Park in South Africa, Kyoto Historic District in Japan, and Quebec City in Canada.

Vermonters can be proud of their wise stewardship of their working landscapes, their villages and towns, their environmental protection policies, their preservation of historic buildings, and their communities. *Vermont Gathering Places* speaks to us of this rare "sense of place" that is Vermont.

Development pressures, environmental problems, civic disengagement, and tourism all threaten communities everywhere. So what accounts for Vermont's success at protecting resources, both man-made and natural that define her part of the world? Vermonters have recognized that their landscapes are special and that they create an atmosphere in which people can have connection even on farms, and in the forests, and mountains. Folks who live in towns meet in the village commons, throughout neighborhoods, and on Main Streets. The social fabric of the community is found here.

The preservation of Vermont's historical buildings and architecture and the landscapes in which these buildings have been placed provide for and foster the gathering of citizens. Schools, stores, churches, grange halls, town halls, and Main Street are all places of social exchange, and in many instances provide the underpinning of democracy. These gathering places are the connection to community that is so threatened today by what some call "progress." In my opinion, "progress" should be the commitment of the populace to preserve and protect against decisions that foster short-term economic growth and to promote the wise use of programs that are sustainable and will assure that Vermont remains a viable and special place in which to live and visit.

As someone who spends a lot of time in my Vermont home it gives me great pleasure to have played a role in producing *Vermont Gathering Places*. I take pride in the assistance that the Preservation Trust has provided to many of the places photographed and described here by Peter Miller. It is my hope that as you go about your daily lives your love of these and other special gathering places will deepen, and that you will join our efforts at the Preservation Trust to protect and enhance them for future generations.

HENRY A. JORDAN, M.D.
President
Preservation Trust of Vermont

In 1971, the two-room Maple Corners School was closed, and residents at town meeting voted to have the school bell moved to the Old West Church. George Morse and Gregory Blecher volunteered for the job and hoisted the bell into its new home. It was rung for the first time as a church bell shortly thereafter at the funeral for Blecher's wife.

Y ou know those Vermont winter days that dawn under a cloudless sky when the temperature is below zero and it's so dry the snow crunches underfoot? When you breath it's like taking a shot of vodka and overhead there is a deep blue of strength and peace and the mountain ridges are sharply etched? There is no wind and it's so still and quiet that it's as if time stops and you feel yourself buoyantly alive?

That was the morning of Saturday, December 18, 2004 in Calais, Vermont. The three-tiered steeple of the Old West Church never seemed so pure against that eternal blue above. The snow was untracked and as white as the church itself. On the driveway grew beds of delicate fairy frost — filigreed leaves of ice that formed when the

numbing cold seeped into moisture. As the sun hit them they sparkled.

George Morse arrived early. A quiet man, white haired, he has tended the church for forty-five years. He carried an armful of kindling he split and some newspaper to help ignite it. On his second trip he brought in a book to read and a chair to sit in. He was the first in the church and set a fire in the box stoves in the back. With such a high ceiling the church never gets warm, but the stoves make it tolerable. George believes the stoves have been here since the 1830s, a few years after the church was built. Back then, the Sunday services were three hours long, and the parishioners brought horse blankets and warmed soapstones to their pews. Finally, someone or a

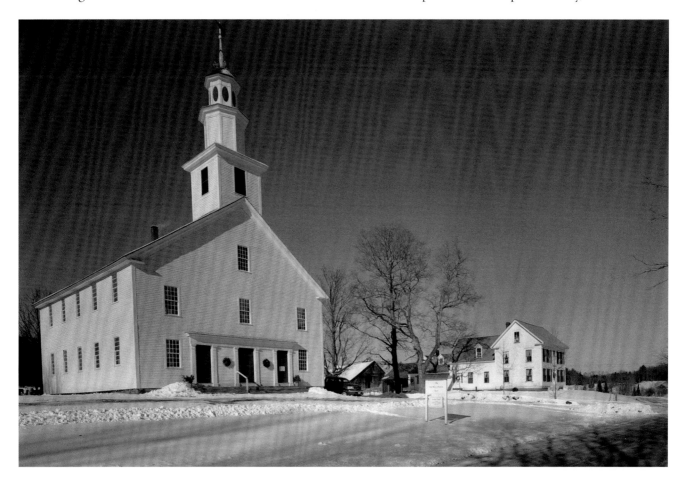

group — it could have been anybody from one of six denominations who used the church and preferred some corporeal comfort on Sunday — removed a few pews and installed the stoves.

This winter morning, the hieroglyphics of frost etched on the south windows dissolved into drops of water as the sun rose and the temperature climbed into the twenties. By noon the windows were dry and clear, accepting of the sharp winter sun, low on the horizon. For 182 years, the large nave with the box pews, the raised pulpit, and the piano in the corner has gathered people for thousands of church services, weddings, baptisms, plays, musical events, funerals, and memorials. And today is no different — there will be one wedding and three separate choir rehearsals.

At one o'clock 1st Lieutenant Kathryn Townsend Purchase, who grew up in Calais, sang in the church choir, and later, on leave from West Point, wore her uniform and read psalms during the candlelit Christmas Eve ceremony, was to marry Captain Jesse Lee Fleming. They met during the first days of the Iraq war, in the dust and swirl of the desert, on the Kuwait–Iraq border, moving quickly at night toward Baghdad, sleeping in Humvees for safety. He was an Apache helicopter pilot who saw some furious action against the Iraq Republican Guard. She was attached to the 864th Engineer Battalion, her job to act as a liaison between helicopter units and the engineers. They both experienced the fierce sandstorms that spit stinging sand and turn the sun blood-red when you can see it, so different from a Vermont snowstorm yet so similar, for when sand and snow die down the world is still and for a short space, purified.

Jesse, his friends and his groomsman, all in their dress blues, waited in the upstairs hallway, which is long and wide and gives access to the balcony pews. A bell rope hung down slackly from a hole in the ceiling. They seemed nervous. Jesse wore a cavalry hat, and all of these men had on ceremonial swords. The interior of the church contains a quiet Shaker simplicity — there is serenity and peace built into this structure; it is comfortable within its space as it faces out onto a mowing and coexists comfortably with a nearby farmhouse.

It was a simple wedding. To the mother's bride Nancy the Old West Church, with its strong straight lines and years of service, is a comforting place, in happy and sad times, and is the compass she carries within herself.

The newly married couple kissed before passing under a saber arch, meant to ensure safe transition into a new life, and walked out of the church into another world, into the backseat of a white stretch Cadillac.

The interior of the church contains a quiet Shaker simplicity — there is serenity and peace built into this structure; it is comfortable within its space as it faces out onto a mowing and coexists comfortably with a nearby farmhouse.

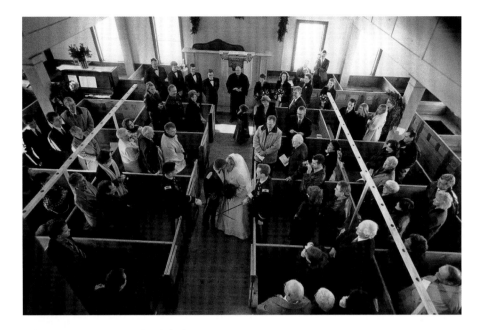

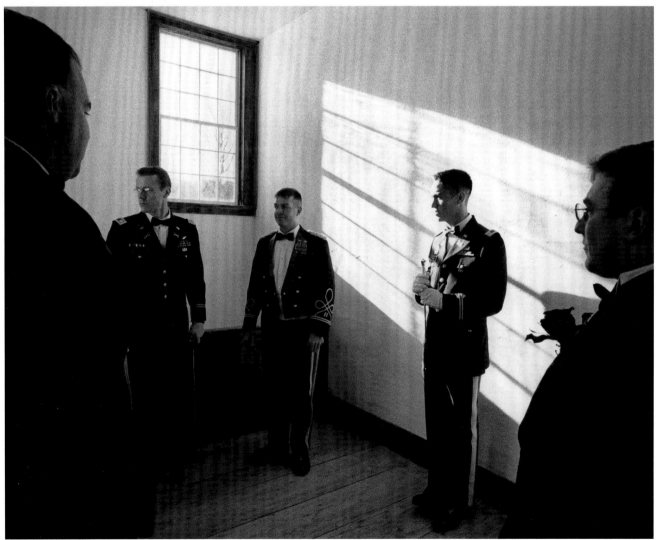

Shortly after the wedding a weather front moved in and obliterated the sky behind flat sheets of dull clouds. A few snowflakes danced and whirled like moths and through the afternoon members of the local choirs — children, youth, and adults — arrived for practice; it is a tradition in Calais to celebrate Christmas Eve at a candlelight ceremony, with the singing of choral songs and reading of psalms.

George Morse stayed intent on his book, stoking the fire, and as evening shrouded the church and the people went home, made sure the fire was out. When he drove out of the driveway the air smelled of snow. The Old West Church, empty of the residents of Calais took on a ghostly quality, dignified and stately as the day faded into the twilight and silence of winter.

Jesse and Kathryn had a brief honeymoon in Paris. He then went back to his helicopter unit in Germany. Kathryn was assigned to Fort Lewis, Washington, to oversee the maintenance of the heavy earth-moving equipment airlifted out of the war zone. Perhaps their assignments would put them together again in another part of the world. 🎋

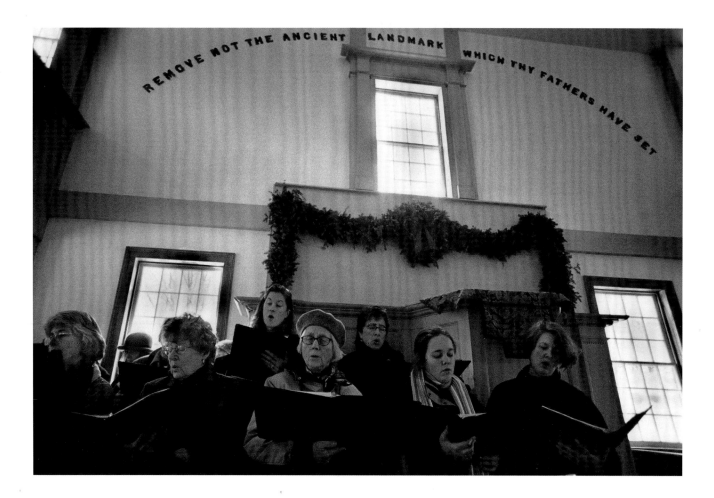

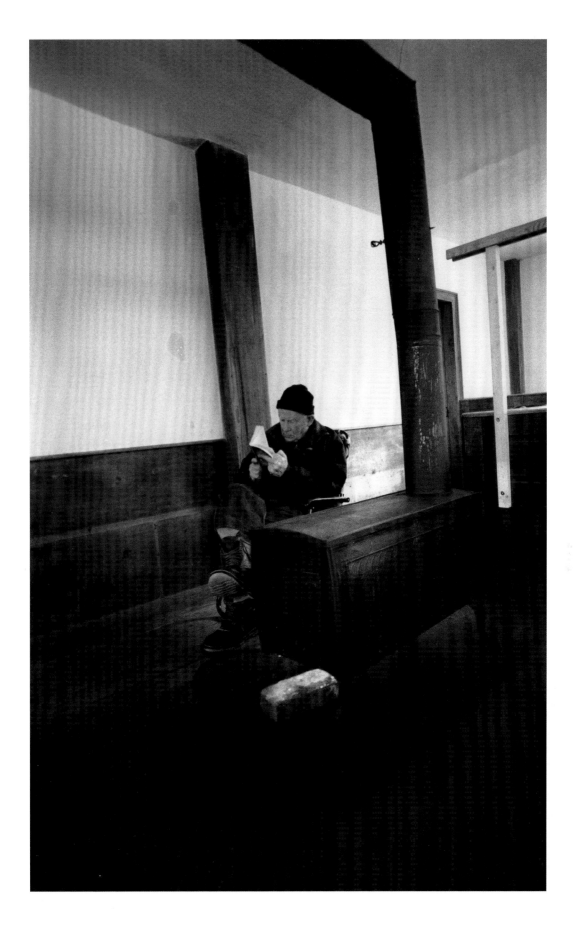

The last weekend of January, when pond ice can add twelve inches in a week, Brookfield residents hold an ice harvest on Sunset Lake next to the famous Floating Bridge (which is icebound, snowbound, and closed). They cut blocks of ice the way Vermonters did before commercial ice harvesting replaced the community effort and then freezers replaced icehouses.

Ice harvesting began in the 1700s and continued until the refrigerator made its way into Vermont homes in the 1940s. It was often a community affair and quite festive. Just about everyone would be on the ice. The men would take turns sawing the ice and tonging it out of the water onto horse-drawn wagons for delivery to residential icehouses around town. The women were in charge of providing a cool picnic of grand proportions. This was a community gathering, and neighbors used the harvest as an excuse to meet together outside, and celebrate, on this last weekend of January, the passing of Vermont's most bitter, frigid, and long month.

The Brookfield Ice Harvest is a relaxed affair. A handwritten sign nailed to a post stuck in the snow says it only costs a buck to enter a contest to see how fast you can hand-cut a block of ice from a T-shaped hole already cut in the ice, tamp your block loose from the ice pack,

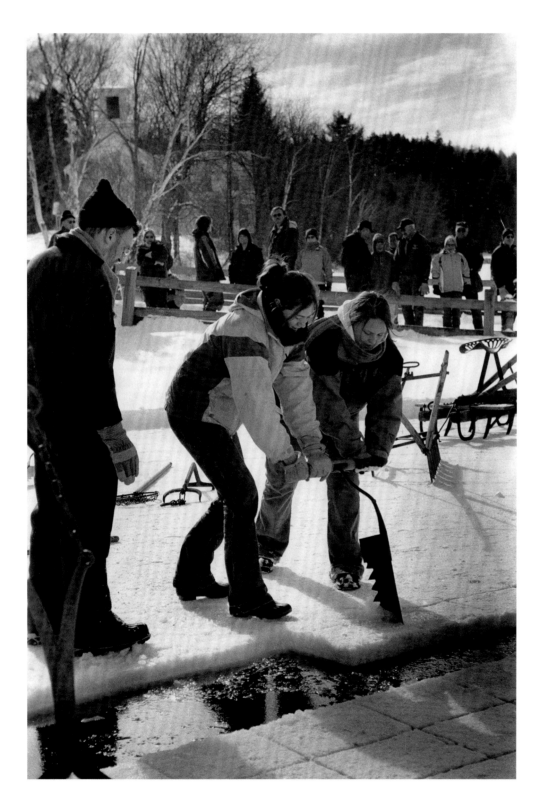

pole it to the ice boom (a fulcrum equipped with a chain and tongs), run around to the rope attached to the top of the fulcrum, raise the ice and swing it to the pile of other blocks. The average block of ice, is about three cubic feet and weighs in at 150 pounds.

There's something very satisfying about ice cutting. It is done in a ritualistic, methodic fashion, using special tools, including the ice saw.

Leighton Detora, a harvest-goer from Stowe, is one who is fascinated with the ice-cutting ritual.

"I've gone many times because it reaches back to a different era with an ethic and level of technology that I missed," he said. "I read about those times and have romanticized about living in this simpler, more rugged era.

"I paid my dollar to compete and of course I didn't win. I even forgot what my time was to cut a block of ice and move it with the boom to the ice pile. I learned that those early Vermonters, who cut the ice all day, did a helluva lot of muscle-straining work. I did one block but those Vermonters did it all day long. I read that it took twenty-five Vermonters a full day to cut twenty-five cords, two-thousand tons of ice blocks. I think of myself at home with a chainsaw and a wagon, cleaning trees on my property, and how little I accomplish."

Back when local and commercial harvesting was the norm, all of the snow was shoveled off the ice so that the cold would set the frozen ponds firm and clear until the ice gleamed as cleanly as a diamond in the sun. Vermonters from this era knew that the best homemade ice cream was frozen with slivers and chips of Vermont pond ice. John Wayne used to favor importing glacier ice from Alaska to put in his drinks; it was squeezed hard and pure and didn't melt quickly. Could say the same for Vermont ice, and today it is about the only Vermont-made product that isn't packaged up fancy and sold for too much on the Internet. ❧

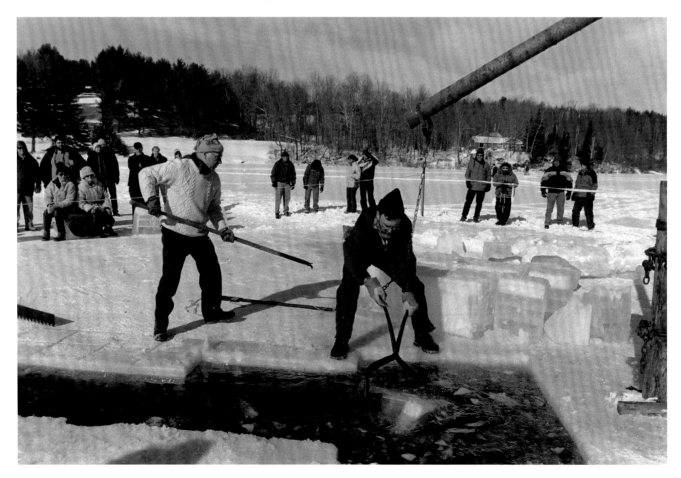

Ever ski in a time warp? There's one hovering over an open pasture of fifty-two acres on the south side of Route 25 near East Corinth. It has a good pitch and goes into time-warp mode soon as the snow falls. There are two rope tows, a 400-footer pulling up kids and a 1,200-footer dragging the older folk up to the top of the hill. Been doing that every winter since 1936. It's the second oldest ski hill in America, after Suicide Six in Woodstock, and America's oldest continually operated tow.

In fact, it's one of the last survivors from a time when skiing was a sport, rather than an industry. Officially Northeast Slopes, locals call it "the ski hill." You won't find any pretenses here; there are no condos and no rentals. Fashion is barnyard practical or snowmobile jazzy. Boards range from no side cut, to goon skis (well

that's what they used to call them), to snowboards, parabolics, and trick skis. Ski technique is what works best.

Want a ski lesson? Jennie gives them free and she's real good with the kids. Taught one young girl how to ride the short rope tow and ski down, told her she's good enough to ski by herself, and she did, and learned to slide and smile without taking one spill.

Hungry? Sue flips the burgers on the outdoor grill on race days. They're only $1.50. And speaking of prices, a day ticket is $12 to ride the big tow, $5 to ride the little one ($3 if eighth grade or younger), and on Wednesday afternoon the price is $1 on the little tow, except for kids, who ski free. School lets out early on

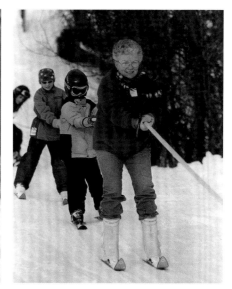
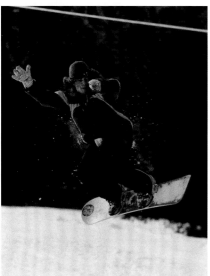

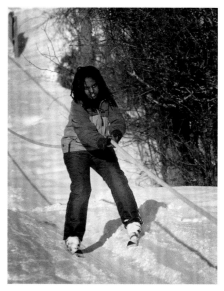

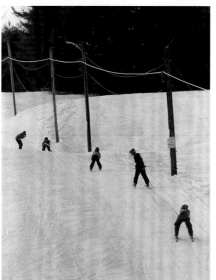
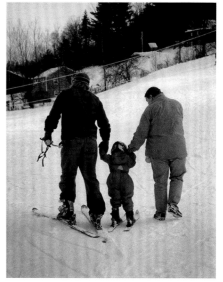

Wednesdays, and the buses bring kids right to the slopes at half-past one.

Forget something? Hats, gloves, and leather pads are for sale in the small warming hut. Leather pads? They prevent the rope tow from shredding your gloves.

On race day young and old mix it up and ski through some gates. There's no timing; first to the finish line wins. Sometimes three racers run at the same time, or snowboarders compete against skiers and occasionally someone will race backward. There's the big air competition and the ski cross, where no more than four race together over jumps and through gates. In the spring the swimmers try the Pond Skim and feast on a barbecued pig.

Northeast Slopes is a nonprofit, run by locals who "just want to keep skiing alive," not only for themselves but for their children. And so do the nearby communities. Bradford and Topsham vote at town meeting each year to give fifty cents per resident for upkeep of the hill.

Corinth recently upped their per-resident contribution to one dollar. Although the finances are tight ($8,200—half of their budget—pays for insurance), they have managed to save and raise enough to put in, this fall, a T-bar.

"You mean you're going to take down the rope tow?"

"Never," said John Pierson, who often volunteers to run the tow and is past president and treasurer of Northeast Slopes. He began skiing by trading his auto mechanic skills for ski tickets for his five children. "We're going to put the T-bar up next to the rope tow and make it three-hundred feet longer. For some of us that rope tow has stretched our arms as far as they can go."

The ski hill has two vehicles to groom the snow, a Thiokol and a crust-buster. In the early days the snow was groomed with a team of horses pulling a harrow. In the summer they have Brush Hog Day: members of the club bring their tractors and brush-cutting machines to give their ski hill its annual shave. ☘

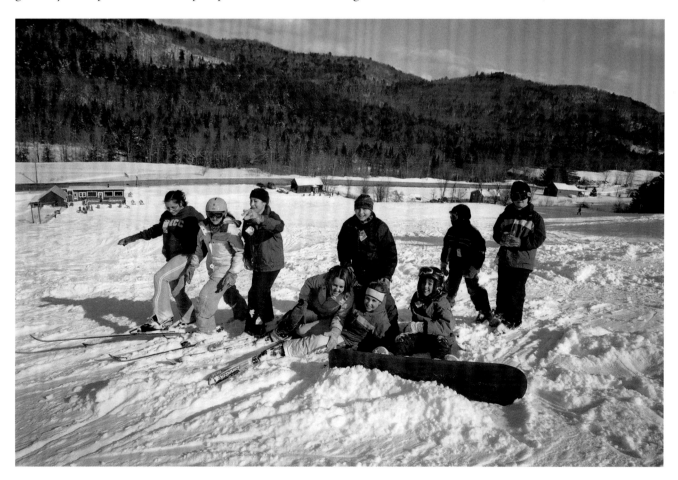

At first glance the Sage Street Mill in North Bennington looks like many of Vermont's used up industrial buildings. It is a plain vanilla, rectangular brick box with a tall chimney standing alone and derelict at one corner, unused for years. The factory was built in the late 1800s, burned down in 1913, and rebuilt in 1926. Laborers produced shirts cuffs and collars, buttons, children's toys, furniture, and later, missile parts and ball valves. In 1994 a young couple bought the factory at auction and resuscitated it as the Vermont Arts Center, an implausible project, one would think, for a town suffering postindustrial lassitude from the loss of factory jobs.

Yet it was perfect timing. Patricia Pedreira and Matthew Perry had the foresight to see that art can transform a community. She has a strong business sense and writes a mean grant application; Matthew is a gifted artist and educator. The brick building's interior is now an airy, gracious, three-level creative arts factory and teaching center called the Vermont Arts Exchange. Paper and printmaking, ceramics, sculpture, drawing, painting, music, and dance are the curricula, and, in large part, the overlooked people of our society are their students. "The arts," said Matthew "are a unique way to reach youth at risk and impaired elders, people who never realized they had creative potential. We also instruct Mercedes-driving matrons. We teach them all the same."

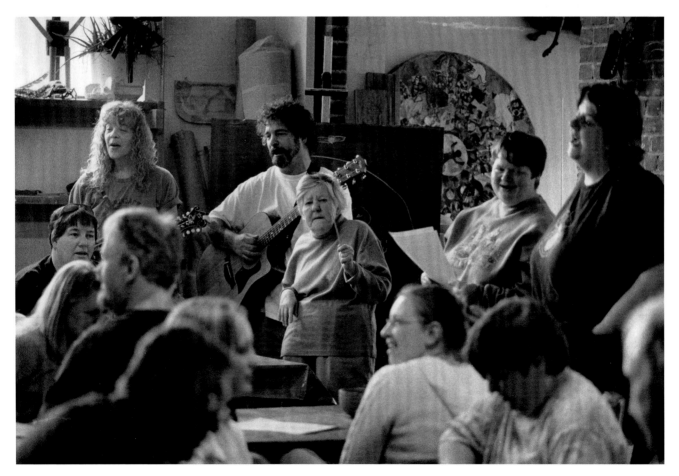

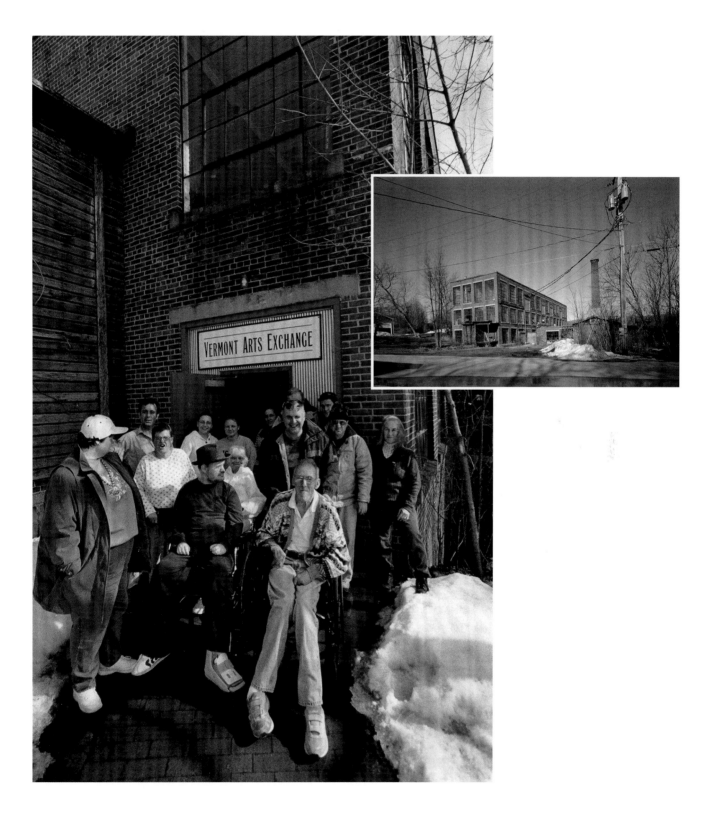

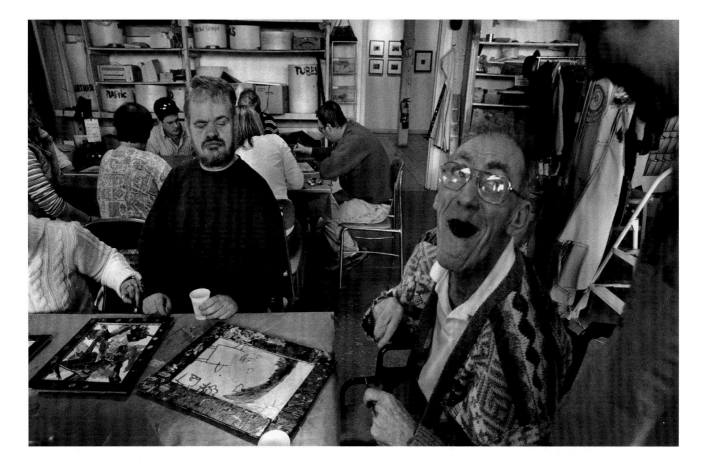

One of Matthew's favorite classes is the Atwood group. There are twelve students in the class and they all have developmental disabilities. They walk or are wheeled into a large workroom of tables and benches cluttered with the tools for making art. They are in good spirits, laughing and telling jokes, and take seats at two long tables where paper, paints and brushes are laid out. Diane stands up and, as she usually does, for she has a warm heart, asks for a round of applause for Deena Smith, one of their music instructors who plays the mandolin. Nathan Knowles, another instructor, tunes up his guitar. Jane steps to the front, faces the table, raises her baton, and the Atwood Group Singers are in action. Stella walks to the front with a big smile and sinks into Hank William's "Your Cheatin' Heart." She sings with so much emotion you want to cry.

It was through the classes at Vermont Arts Exchange that Stella began to sing songs that she has known for a long time. At first she was reluctant to sing at all but

now, said Matthew Perry, Stella has inspired others to get up and sing and dance.

Music is very important to this group, for melodies and lyrics trigger memories and open up the past. Now the Atwood Group Singers have made a CD. "The artists are finding out that they have talent. They're realizing they can do anything." When they made the CD, another student, Perry, who is blind, played the piano and the teachers laid a tract over her song. At a reception the CD was played and the Atwood group showed off their painting, ceramics and jewelry. Thelma, who sings the lead vocals on "Jeremiah was a Bullfrog" on the CD, exhibited a painting of seashore ravaged by a tsunami.

Back in the classroom the singing ends and they begin painting in the Picasso sense — straight out of their minds. Later they create constructions. Matthew, who is also artistic director of the Vermont Arts Exchange, stands beside them helping and praising their work.

"We have high quality artists and the facility to teach

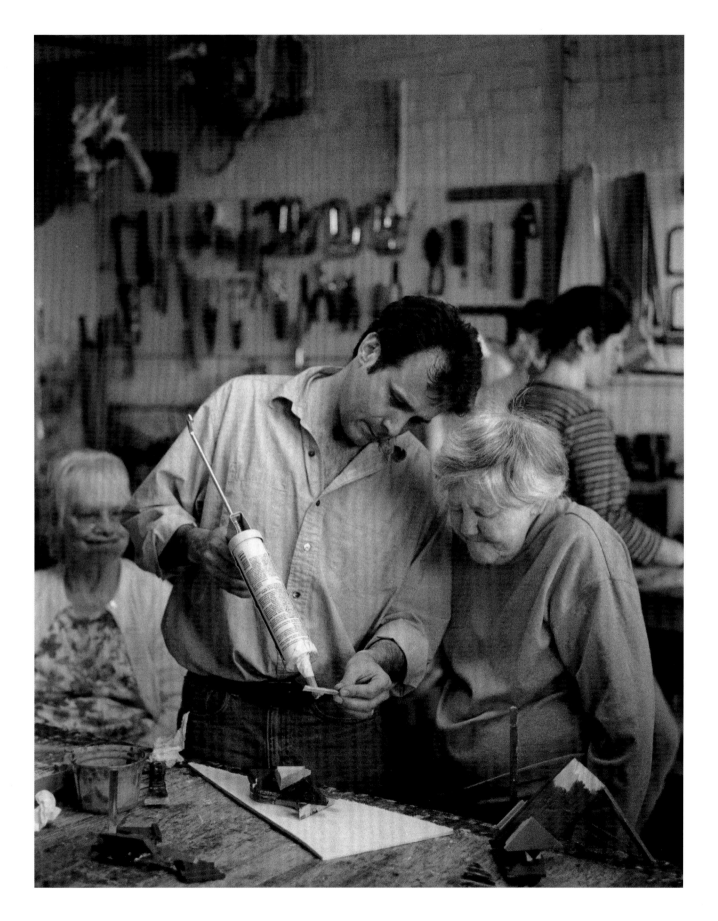

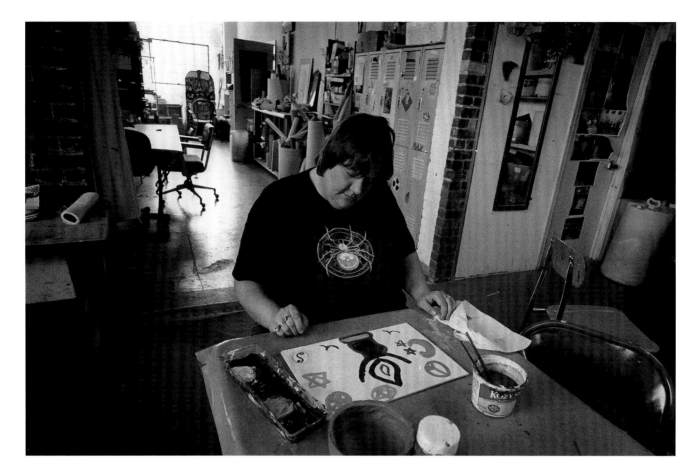

them the same as we would a Bennington College student," said Matthew. "Even though some of them lack motor skills to hold a brush correctly, we just forget about disabilities and do the art. It's the same when we work with the Vermont Veteran's Home, or the Tewksbury Hospital in Massachusetts or with individuals. . . . I do not like to call their work "outside art," as the critics have named it. I find untrained arts by some punk kids or an elder is refreshing; there is no bullshit in their work."

Robert Pini, whose statewide service United Counseling works with the Vermont Arts Exchange, is amazed at what the group has accomplished in a year. "Thirty years ago, people with disabilities were institutionalized and out of the community. Now they have many places in the community to gather, to receive services, build personalities, expand social networks, and acquire job skills and, as the students at the Vermont Arts Exchange have proven, they are discovering their creative passions." ❧

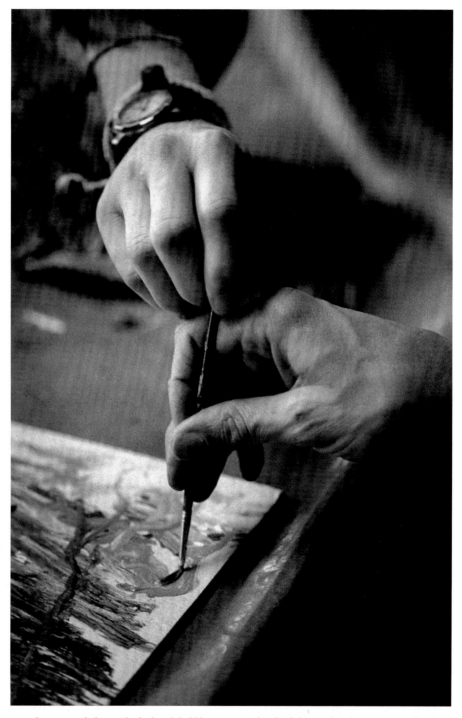

Matthew Perry helps guide the brush held by a man with a disability. "A big thing is trust. They have to trust you and be used to coming here to become comfortable with what they are doing and relate to the teacher."

TOWN MEETING
Moretown

Dry snow fell during the night, but with daylight it had changed into plump, moist flakes that coated tree branches; about five inches fell in the valley, more on the mountaintops. The new snow cleansed the dirty snowbanks and hinted that the bitter winter is past and maple sugaring season is on its way.

It is Tuesday, March 1, 2005, Town Meeting Day throughout Vermont. In Moretown, scattered groups of people are entering the 170-year-old town hall, across the road from the country store. First to arrive is the custodian, to make sure the furnace is heating. Then comes Susan Goodyear, the town clerk, and other officials in charge of voting. They control the voter list and are careful to check off the voters before they are given their ballots and then again after they vote.

The town hall is a theater, as it is in most Vermont small towns (Moretown is proud of its recently restored, hand-painted stage curtain). Folding chairs fill the hall and on

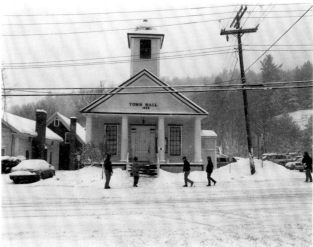

the stage are the voting booths, tables, and, next to an American flag, a podium facing the empty seats.

Town moderator Jerry Maynard arrives with his notes, a town meeting report, a gavel, and his reading glasses, which he places on the podium. He is the umpire of the town meeting and has been for the last eight years. A town moderator must have a thorough knowledge of Robert's Rules of Order for without a protocol to follow, says Jerry, "There would be chaos." He makes sure the discussion and voting follow the issues in the town report. And it helps to have a sense of humor.

Once a year Jerry attends a one-day seminar organized by the Vermont secretary of state for town moderators. He also presides over the pre-town meeting to discuss the warnings that are in the town report and voted upon by Australian ballot.

On the floor just in front of the proscenium is a long table where the selectman will sit. If the voters decide an issue requires a paper ballot rather than vocal yeas and nays, the ballots can be stuffed in a ballot box on this table.

In the downstairs kitchen women from the historical society are preparing sandwiches, corn chowder, and meatloaf, and are putting out the cookies and brownies they baked the night before.

The town hall slowly fills; the one hundred chairs are taken; by midmorning it will be standing room only. At 9 A.M. Jerry bangs the gavel and town meeting begins with an invocation.

Town meeting, as it is practiced in Vermont, is a gathering of local citizens who cast their votes individually, with discussion beforehand, on all the matters that pertain to their town — how to spend their tax money and whether to buy a new fire truck or fix the old one, support the school budget, put a new furnace in the town

hall, elect town officials, or pass a resolution that reflects the will of the majority of the town's voters. As such, it is a legislative body and the purest form of democracy whose roots go back to Athens in 400 B.C. (at least six thousand citizens were required to achieve a quorum, but women and slaves did not have the right to vote).

Perhaps the best definition of town meeting is in the book *All Those in Favor: Rediscovering the Secrets of Town Meeting and Community*, by Susan Clark and Frank Bryan (2005, RavenMark): ". . . in town meeting governments, no elected representatives intervene between the citizen and what the government says or how it acts." In other words, no representatives, no ringers, no lobbyists, no party line discipline, no red tape or compromise muddle the individual vote.

The first town meeting in America was in Massachusetts in 1633, the first in Vermont was held in Benning-

ton in 1762 — fifteen years before Vermont became a state. Moretown held its inaugural town meeting in 1792 in the parlor of the Haseltine home.

Moretown is the only town in the country with such a name, a name compounded from More and Town. There is a shaggy dog story about the name that involves one of the town's forefathers, who was a selectman, a pair of snowshoes, and a bobcat. Some people call the town No Man's Land because it's near the wealthy resort towns of Waitsfield and Warren.

Moretown extends over six square miles of mountains, fields, and two rivers. The population of the town in 1791 was 24. By 1860 it reached 1,410, then decreased, by 1925, to 930. In 2000 the population was 1,637. Moretown has no restaurant or bar, one lawyer, and the doctors who live in town practice elsewhere.

"We used to be dairy farms and lumber mills and

Moretown was a company town," said Susan Goodyear, the very savvy town clerk, a job she has won for the for the past nine years. (town clerk is an elected position, voted upon at town meeting).

"A lot of young people have moved in. They are professional people, educators, and state employees and they work in Montpelier, Waterbury, and Burlington. There is a trend for one person to stay home and raise the family.

"The new people," said Susan, "like to get on to town or school committees. Their expectation is that, when they move here they can get the same facilities as elsewhere, such as new public tennis courts or a playground. Not too long ago if you wanted that you put them in your backyard, not on town land.

"A lot of people are very conservative. Some of the elders have little income, and when taxes go up, they are in trouble and could lose their homes. Rising property values mean the young cannot afford, in many cases, to buy property in their hometown. An old farmhouse with three-tenths of an acre is taxed at $3,720, is valued at $250,000, and would probably sell for more than that.

"But we have a good mixture of people," she continues. "Our elementary school is excellent, and many parents are involved. The school is a way to get to know people, as are the churches and town meeting.

"Town meeting may be in trouble in other towns, but it is not dying in Moretown. There is a lot of interest in our town meeting."

However, at the 2005 town meeting there was no lively discussion of how much of the tax dollar should be spent on the school and town budget because those items were on the Australian ballot. So smaller issues such as how much money is appropriated to certain services or when the taxes are due were discussed and voted upon.

Attendance at town meetings is down; about one in five voters participate. In Moretown 100 of 1,266 voters were at the meeting, but 446 used the Australian ballot, one of the highest percentages in the state.

Low attendance at town meeting can be attributed to both the Australian ballot and the fact that not many Vermonters have the day off. The Vermont legislature could legislate Town Meeting Day into an official holiday. After all, Vermont marks Bennington Battle Day an official holiday, memorializing a battle that actually took place in New York.

There's a certain feeling in a town hall on Town Meeting Day. The chairs are uncomfortable, the temperature too hot or cold, and it may be too crowded. But there's a real satisfaction in being in a room as the people of a town shape their own government. There's opportunity to vote or express your views, to discuss

opinions with neighbors, in private or on the floor, to partake of a lunch, and to be part of the most important town gathering of the year.

The most widely discussed warning at Moretown in 2005 was a resolution to limit federal control over the Vermont National Guard, to investigate whether the Guard has been called up in conformity with the U.S. Constitution, and to encourage the president and Congress to take steps to withdraw American troops from Iraq.

There was lively debate on whether the resolution was demeaning American troops. A fifteen-year-old high school sophomore spoke eloquently about the war (being too young to vote, a floor vote was required to grant her permission to speak). A combat veteran from another war spoke for the resolution, as did the wife of a National Guardsman who was just deployed for eighteen months. One man spoke with conviction that

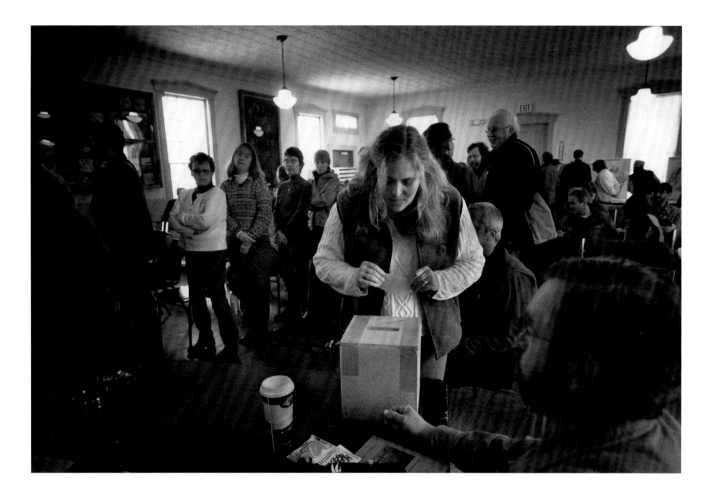

the resolution sent a bad message to our troops and a
good message to the terrorists. A few others thought so
too and the voters opted for a paper ballot instead of a
yea and nay vote. The town voted 64–19 in favor of the
resolution and the people's vote — 51 other Vermont
towns also added the resolution to their town meeting
agenda — made the national newspapers. ❧

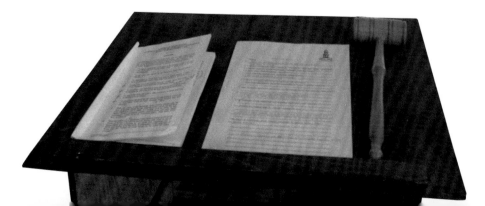

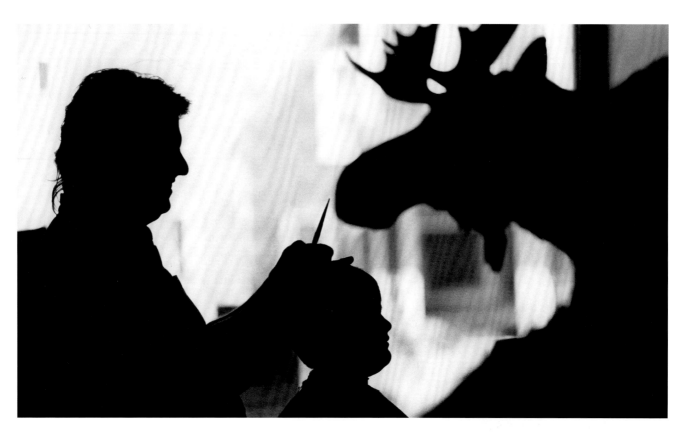

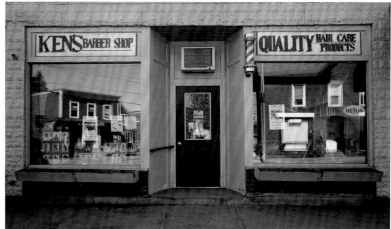

Believe it or not, there is a
Ken's Barber Shop Quartet.
Occasionally they come in on Saturday mornings to
practice and entertain the customers.

The four chairs at Ken's are full up, and there's a bunch of people waiting, seated along the opposite wall, noses in outdoor magazines. The conversation flips about on how many bucks a hunter should be allowed to shoot in a season — the law is about to change. Mothers and their children sit in the corner, separated from the men by the cash register and a box of lollipops. Strewn on the floor are boxes of toys. Near the front window, overwhelmed by a large stuffed moose head, is Tom, who bought the business from his father. He shot the moose in nearby Tunbridge. Next to him is Jeff, whose father was a barber in Randolph, and sold his business to Ken. Then there is Ken and in the rear corner is Sue, Ken's fiancée. She's the first woman barber in the history of Randolph.

"How many customers do you have?" I asked Ken, who opened for business in 1985.

"Gosh, I don't know," he replied. "Maybe fourteen hundred, maybe more. They come from all over— Braintree, Rochester, Bethel, South Royalton. Maybe five thousand. Who knows?"

Price of a cut is $8.50 for kids, $9.00 for adults. It's spring and, judging from the trimmings on the floor, a lot of customers are shortening their winter growth.

Sue is shaping a woman's hair, her children are waiting their turn. They run back and forth from the boxes of toys to the barber chair their mom is in.

"I was a hairdresser when I came here in 1989," said Sue. "The men didn't like me being in the barber shop. In fact some told me to go back to where I came from, that I didn't belong here."

"Well Ken told them I'm a barber, just like the rest of them. Now my men customers are about half of my business. When I started it was ladies and kids.

"I'm studying clinical psychology. Maybe I can teach those men to understand! No, I'm kidding!" she said with a quick smile. "I'm going to be a family therapist."

The age spread of those who have their hair cut at Ken's range from seven months to one hundred years. The older ones are the most traditional; they want a man to shorten their locks. ❧

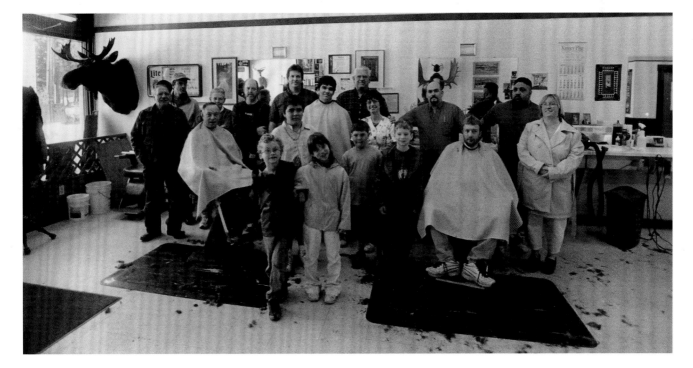

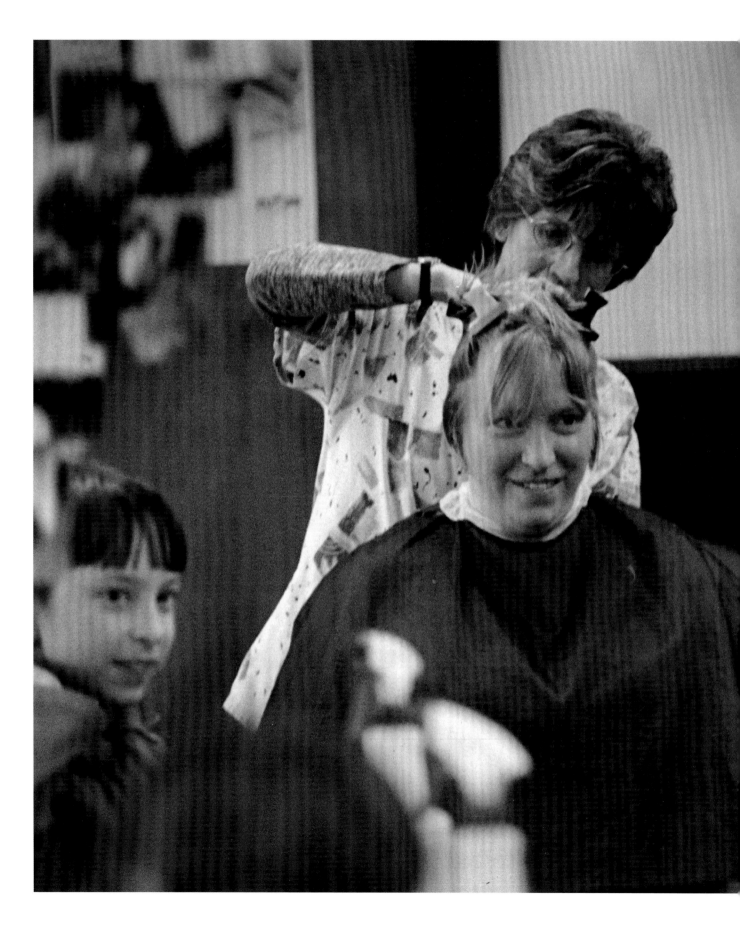

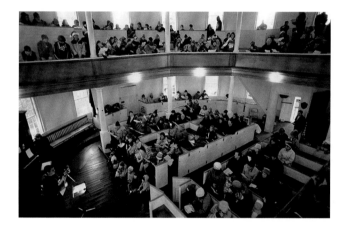

Y*ou better watch out,*

You better not cry,

Better not pout, I'm telling you why,

Santa Claus is coming to town.

The way the kids and the parents are going at it you'd think the Richmond Round Church might pop its lid. This is a rollicking, boisterous Christmas carol session that would make Bruce Springsteen proud, and what a location — a round church (actually a sixteen-sided polygon). Not heated. The kids are kneeling on the floor and in the front pew, bundled in scarves and ski jackets. They wear bright, wide smiles and are not a bit shy. Carol master Tom Walters leads the songs as he plays his guitar. The church is packed and there's standing room only both upstairs and down.

He sees you when you're sleeping,

He knows when you're awake,

He knows if you've been bad or good,

So be good for goodness sake!

The kid's session ends, the building stops reverberating, and the grownups sing about the happenings in Bethlehem. There's a mellowness to the songs in this church that acoustically favors music, but not the spoken word. The church is like a mother hen, protective and caring of its flock, especially at Christmas.

The construction of the church was completed in 1813, built round, as the legend says, ". . . so there would be no corners for Satan to hide." It was one of the first community churches in America, serving five denominations. Its graceful lines even attracted Henry Ford, who wanted to move the building to Michigan. Declined!

Town meeting was held here for 160 years, until disrepair forced public meetings to be banned from the site

34

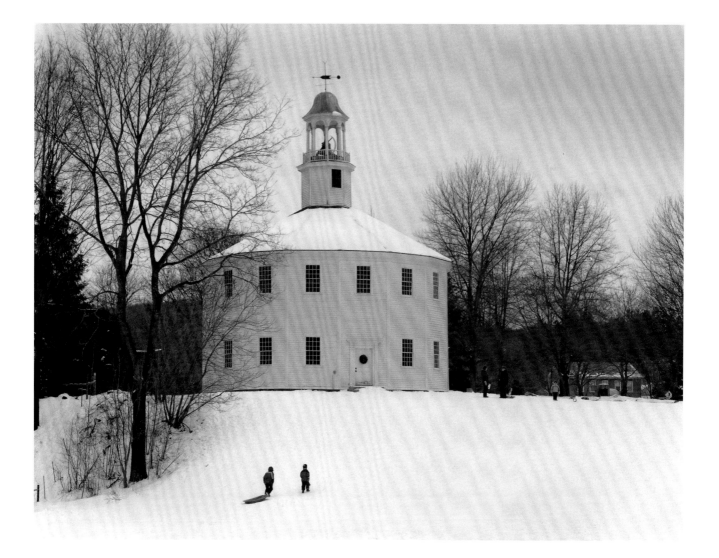

in 1973. Given to the Richmond Historical Society three years later, the Church has been restored and is now the site for weddings and other social and musical gatherings.

Recently, a prayer service on the second anniversary of the War in Iraq — March 19, 2005 — was organized by Reverend Barbara Purinton, whose husband is a chaplain for the Vermont National Guard, now on his way to Iraq. Her daughter, also in the Vermont National Guard, is on a security mission in Kuwait. People from different faiths stood in the soft afternoon light and read their prayers.

We hold in our hearts and prayers all troops and military personnel and all of those who have died since the Iraq war began.

We hold in our hearts and prayers the many thousands who have returned from the war with physical and mental injuries.

We hold in our hearts and prayers the hundreds of thousands of Iraqis who have suffered deprivation and death . . . God of Grace hear our cries. We long for an end to the hostilities and sorrow.

In the hour-long remembrance, the word peace was mentioned thirty-five times and freedom mentioned once. The words terror, liberty, patriotism, and democracy were never uttered. ❧

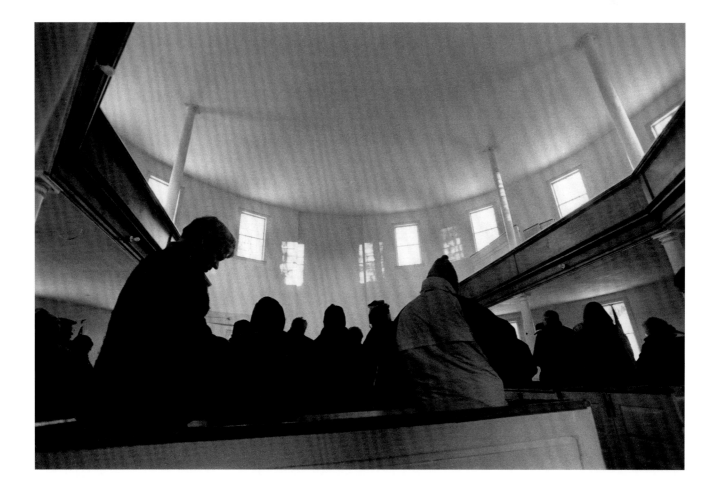

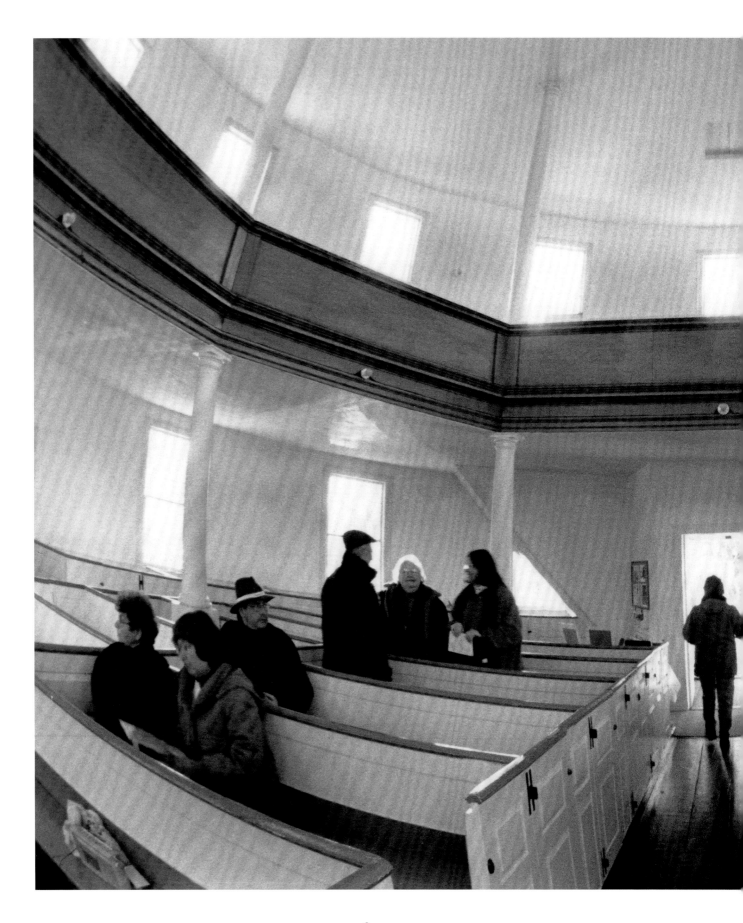

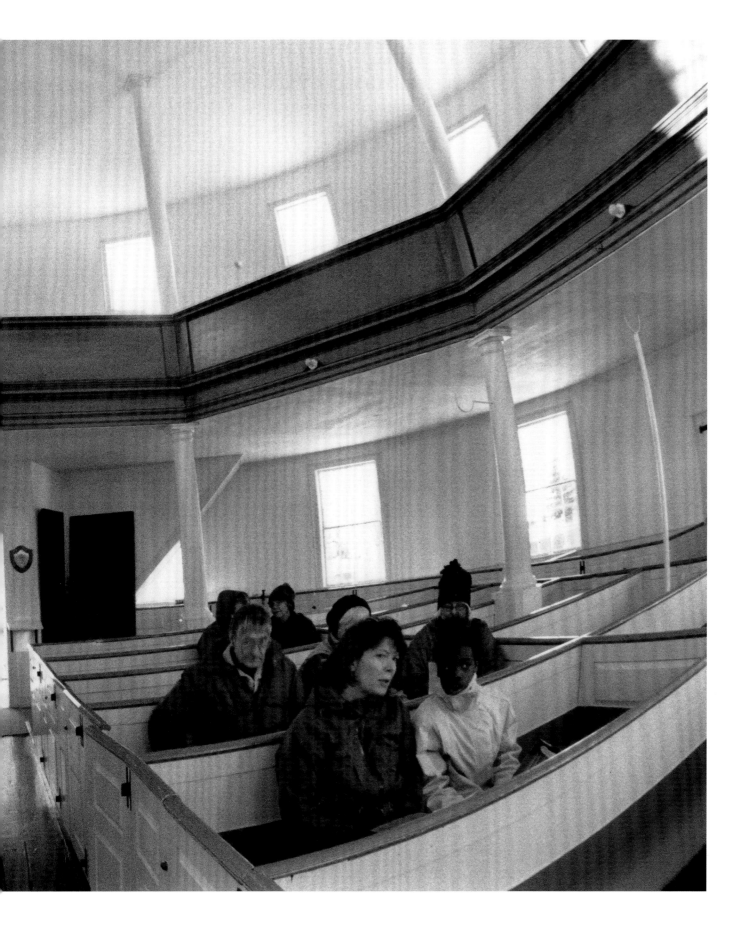

COMMUNITY CHURCH SUPPER
Pawlet

It's April and miserable with a cold mist rain. The Flower Brook is rushing with snowmelt, its roar a harbinger of better times to come. Over the brook there is a bridge, just outside of town, and on it is a sign: CHURCH SUPPER TONIGHT. The freshly painted belfry and four sharp finials of the Pawlet Community Church peep over the excited stream and the very small and funky town of Pawlet. The belfry, finials, and paint job are new. Roast pig paid for most of it.

"This church was built in 1853 and through the years water seeped into the old belfry," said Reverend Robert Boutwell. "It rotted the timbers and the cradle that holds the bell. We were afraid to ring the bell so we didn't."

The church itself is a simple, airy, large, open room with graceful stained-glass windows and pressed-tin ceiling and walls, something more often seen in century-old bars.

For years this community church has sponsored, in its downstairs, a monthly dinner from April through November, cooked in their kitchen—roast pork and

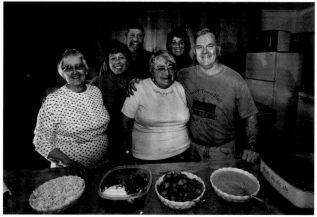

dressing, green peas, mashed potatoes and gravy, coleslaw, buns, punch, and coffee. Only nine dollars and you're welcome to seconds. Although the church only has one hundred members and Pastor Bob is part-time (all day Sundays and Wednesday, on call anytime) 150 people show up every month for the dinner. It is the same comfort food every month, but the dessert changes by the season. April featured vanilla ice cream with new maple syrup and a cherry on top.

Over time the dinners raised thirty-five thousand dollars to repair the belfry. "There was enough to have the belfry rebuilt and the finials reproduced. We used old photographs for accuracy," said Pastor Bob. "It was put together in Barre and brought down on a flatbed. A derrick lifted it up. We could even afford to paint the church. We rang the re-cradled bell for the first time in June 2004."

"Now our suppers are raising money for a new carpet for the sanctuary." ❧

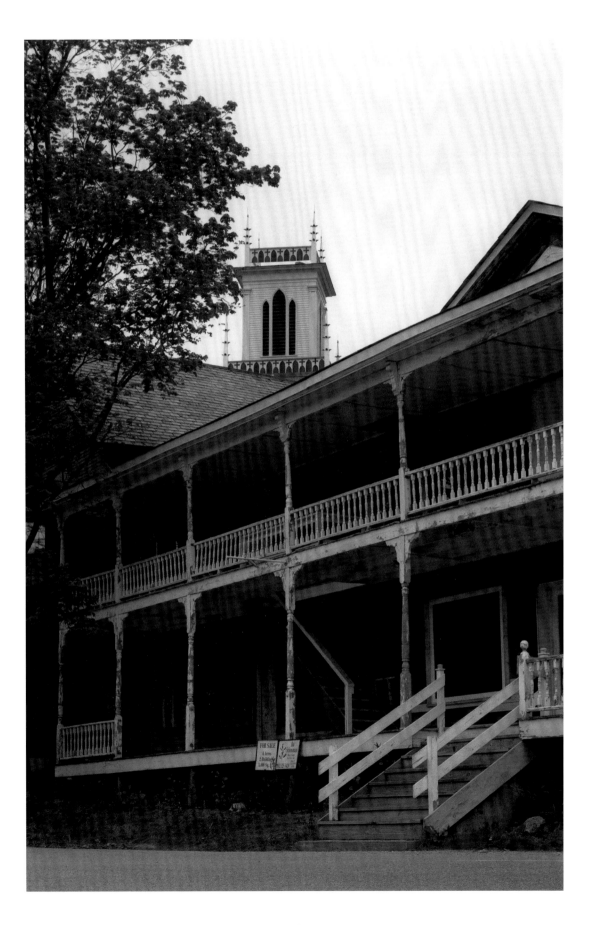

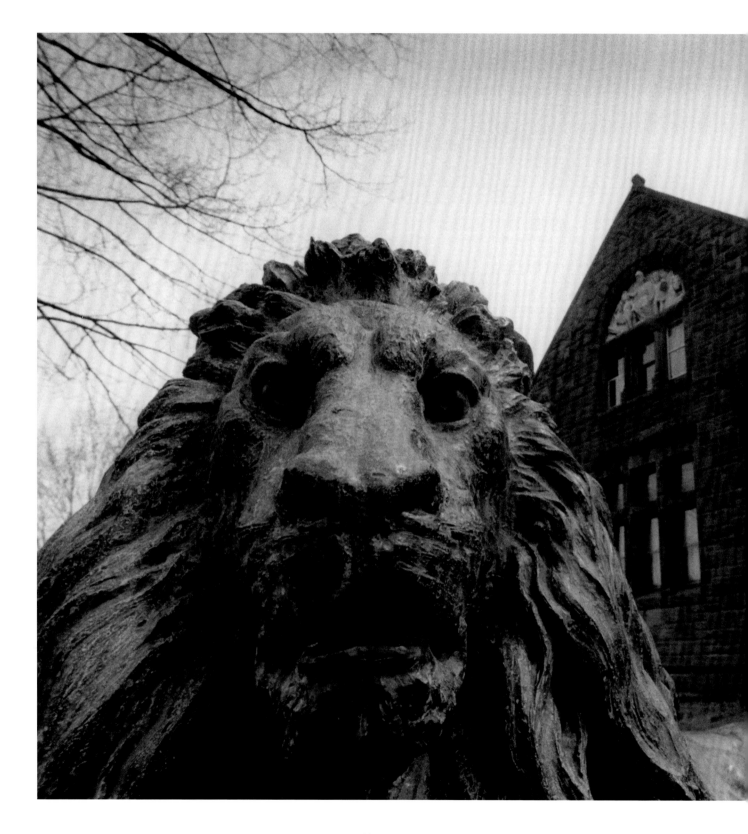

FAIRBANKS MUSEUM
St. Johnsbury

Harry scurried under the snarling polar bear, ran past the deadly black mamba before it could strike, turned right, and skipped over the tarantula. He skidded to a stop as the menacing Dobsonfly raised its pincers. Harry spun around and retreated, the huge, buzzing insect — the size of a vulture — in close pursuit. Harry was bug-eyed, his goggle glasses were steamed, and his hair tousled. He slid to a halt, spun around, and made a face at the fast-closing insect, then disappeared down a dark and mysterious passageway. Could it really be . . . ?

Every year twenty-seven thousand school children take classes at the Fairbanks Museum in St. Johnsbury, another 50,000 tourists and parents visit with their children. This turreted, Victorian building — gargoyles glare down at two bronze lions that guard the entrance, one toothless, the other snarling — is the sort of place where the past becomes the present and the imagination soars. Wide-eyed dolls hypnotize those who meet their gaze for longer than ten seconds, a mummy case with a young woman painted on it smiles sickly at puns, while snipes, eagles, and a 125-year-old ivory-billed wood-pecker (along with 2,997 other stuffed bird specimens) fly in formation back and forth under the barrel-vaulted oak ceiling. A great place for kids, for Halloween, and for learning.

This museum was originally called a "cabinet of curiosities," the result of Franklin Fairbanks' lifelong curiosity in what inhabits this earth and why. Franklin, the last of the Fairbanks to be president of the scale company his father and uncle founded and that made

the family fortune, built the museum in 1891 and stocked it with his growing collection. From the beginning he believed the only reason for the 175,000 natural science, historical, and cultural items he collected from all over the world was to inspire in the young the curiosity that shaped his own life.

The museum also has a planetarium and a downstairs weather-reporting station featuring the *Eye on the Sky*. Heard on radio stations throughout the state, the *Eye on the Sky* is broadcast to ten million listeners annually. Meteorologists Steve Maleski and Mark Breen also give weather forecasting lectures and have designed a new high-tech teaching lab with interactive computers. Franklin began recording weather data in 1894. Since

then, St. Johnsbury has warmed up by nearly two and a half degrees.

Perhaps not as many Vermonters as out-of-staters are familiar with the museum's famous collection of bug art, shown at the 1850s World's Fair. Created by John Hampson, who worked with Thomas Edison on inventing the phonograph and the internal-combustion engine, the collection features Japanese beetles, many, many moths, and field and cabbage flies in mosaics that represent the American flag, along with presidents and generals in patriotic poses. The museum houses all of Hampson's bug art creations, which are made of between 6,000 and 13,000 common insects. People from all over the country are attracted like moths to the collection. ❧

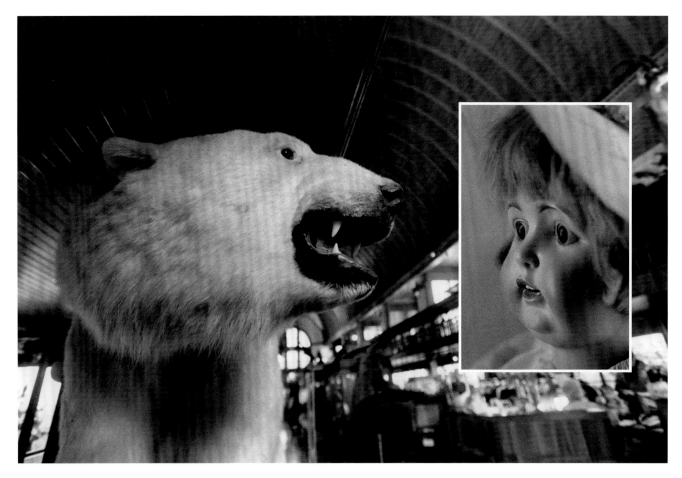

Kids who fish know what a hellgrammite is—an ugly, centipede-type insect with mandibles that try to bite you. They live under rocks in moving water. Place them on a hook and drift them downstream; trout and bass love them. Hellgrammites emerge into the Dobsonfly, a nasty looking species with even bigger pincers. This oversize bronze casting is of a Dobson on the defensive; he's is about to be attacked by one of his siblings. It took seven years to create what is everyone's nightmare of a vampire insect about to go berserk. Except, of course, for kids.

Although town meetings are where Vermonters vote on how they wish to be governed, chances are the issues were first thrashed out in the nearby country store.

In fact, just about everything that happens in a Vermont village is discussed at the country store — they are the hard drive of Vermont's small communities.

So just what is a country store? Simply said, it is a small store, which, in its individual fashion, sells products to the community. Its outer skin is usually in the form of a classic piece of Vermont architecture, a wood-frame building with well-balanced proportions. Many were built over one hundred years ago (the Vermont Alliance of Independent Country Stores only allows members whose buildings predate 1927, the year of the great Vermont flood).

The proprietors are individuals, most often a couple, who stand behind the counter and sweep the floors. They have an aversion to franchises and corporations who dictate how to manage a store and what candies and potato chips to sell. It is why many country stores no longer sell gas, as they would not accept the canopy covering the pumps the gas companies wanted to erect. The owners work seventy to eighty hours a week; their calling, as it is with dairy farmers, is a way of life. It also is a passion, otherwise they would allow their charges to molt into gleaming, junk-food convenience stores (I call them "That's It?" stores, named for the only phrase some cashiers utter before ringing up the sale), or die off in the face of malls and the big box stores.

Country stores provide the community with an eclectic inventory. Milk, eggs, cheese, Pampers, peanut butter, chewing tobacco and roll-your-own, vegetables and meat, ice cream and homemade pies, sandwiches and Scotch tape, beer, V8 juice, Diet Coke and, of course, newspapers. Some stores have low-cost sections with items customers need now: clothespins, pencils and pens, notepads, bug repellent, razors and scissors, tacks and pins and glue, toothbrushes and combs. None sell dynamite, kegs of nails, or carloads of barbed wire, as they used to, but they can order such things as lemon-flavored cod-liver oil or a case of premier cru Bordeaux wine.

The modern country stores offer hot foods and have a deli. A few are owned by butchers renowned for their cuts of beef. They sell hunting and fishing licenses and some stock guns and ammo.

The storeowners know their regular customers by name, as they are also neighbors and they may just be running a tab. On the counter petitions about town affairs are clamped to clipboards, which customers sign or choose not to sign. The bulletin board on the outside of the store next to the door is the local classified; everyone reads it. As Jane Beck said in her wonderful book, *The General Store in Vermont: An Oral History* (The Vermont Folklife Center, Middlebury, Vermont), "Besides being a distributor of goods, the country store has served as a post office, lending bank, barber shop, polling center, and community center."

In the past the country stores often had the latest Edison records, if not the first phonograph, and may well have been the only place in town with incandescent lightbulbs. Their first telephones were crank-ups and anyone could listen in on the party line. The storeowner

often bought the first Model T Ford and was the first to find out that horses work better during mud season. Nowadays a few stores have ATMs, sell computer necessities and prepaid calling cards, and often control their inventory on sophisticated software. Broadband computer stations stuck in the corner next to the garden seeds will be the next development.

Spend a few hours seated in a country store or outside on the bench (there is always a bench). Drink your coffee or lick an ice cream cone. Speak to the locals who are hanging about. Pretty quickly a profile of the community emerges, distilled from the people you meet, be they summer residents, transplants, roofers or farmers, mothers or teachers. The native Vermonter has a terse sense of humor. Get them going on what they think of management of the deer herd. All will roll their eyes when they discuss rising real estate prices and the cost of fuel oil. If someone in town is driving around in a Hummer, you're sure to learn more about that person than you care to. All this talk is a mirror of the community — a sense of belonging, a sense of place.

Not too often do towns and their residents realize the value of a country store until it is gone. Vermont country stores are, along with native Vermonters, an endangered species. Few towns or land trusts support country stores, even though they are often located in historical buildings, and the store is a keystone for the community. In England, towns have purchased country stores and leased them at modest rent to storekeepers. This is also working in New Hampshire. Towns should look to preserving their country stores, for without them the spirit of each small Vermont community will wither, like a girdled tree.

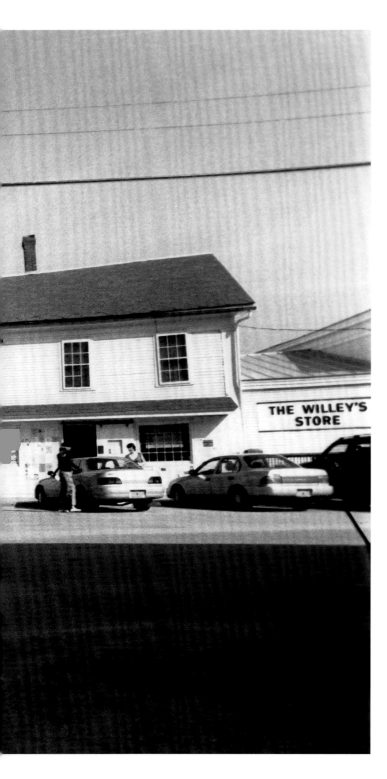

THE WILLEY'S STORE, GREENSBORO
Tom Hurst

In the off-season Greensboro is so quiet you can ride a horse down Main Street. Come summer the houses on the lake fill with professors, writers, and families that have summered in Greensboro for generations. Willey's is one of Vermont's most famous country stores, along with Dan and Whit's in Norwich. "If Willey's doesn't have it, you don't need it," is the store's unwritten motto.

"Well," said Tom, "that's not true. We don't sell satellite dishes, suitcases, or lumber. But we do carry strike anywhere matches."

The Willey's Store has been in Tom's family since 1900 when his great-great-grandfather bought it. Tom's mother, Phyllis Willey Hurst, was born in the building, and — except for a brief hiatus to attend college, meet and marry Tom's father and teach music — she has spent all of her 87 years helping run the family business. Ernie Hurst, Tom's father, is best remembered for his whistling, which could be heard throughout the store from his position behind the meat counter.

Willey's sells everything from boots and bow hunting supplies to champagne, motor oil, fishing worms, and filet mignon. They cut keys, make photocopies, and offer a public fax. In fact, the store is so complete that a summer resident never has to leave town to shop. And the staff — Ed Miller has forty years experience burrowing in the hardware department — knows where to find size-15 widgets.

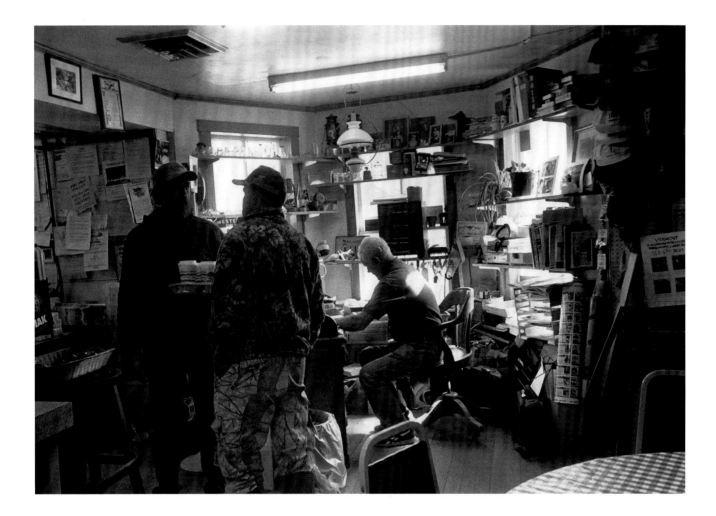

Wayside Country Store, West Arlington
Doug and Nancy Tschorn

Every morning locals come in and sit in a formation known as Knights of the Round Table. Ray Smith is often seated there.

"My father and grandfather ran this store. Father had a roll top desk right where Doug works. I lived upstairs and could climb the kitchen roof to my bedroom and my folks would not know I had sneaked out.

"After WWII we had quite a bit of merchandise in the store and my father wanted to make room for new inventory. He decided to have a liquidation sale and needed a good promotion to get people there. Well, several years before, my grandfather had given me a rooster and a hen, and we had a backyard full of chickens that my mother was ready to see go. So my father advertised a Chicken Throw in the paper for Saturday October 22, 1949. On that day we gathered up the chickens and tied dollar bills to their legs. Then a bunch of us went up onto the roof and threw the chickens off. Whoever caught them got to keep the chicken and the money. A huge crowd showed up and Norman Rockwell's son Thomas photographed it and the picture ran full page in the *Bennington Banner*. We sold almost everything in the store, too."

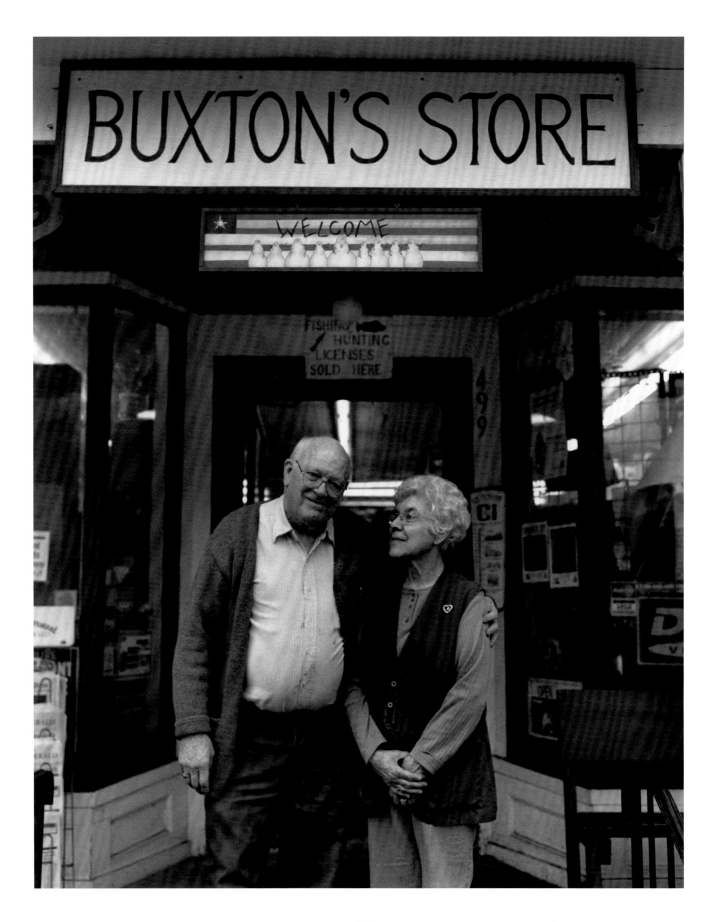

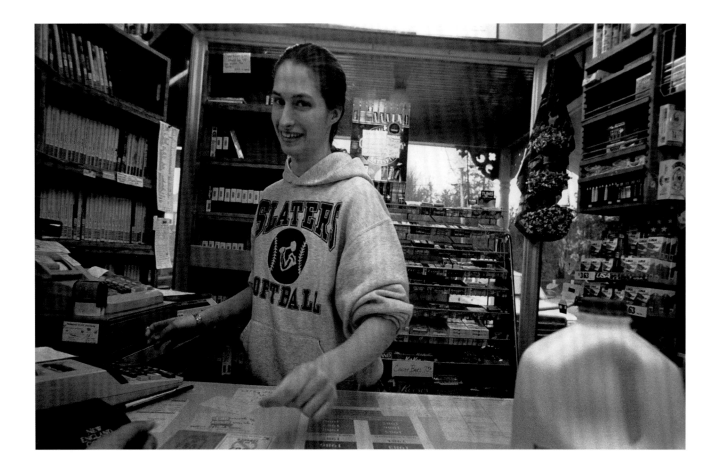

BUXTON'S STORE, ORWELL
Thelma and Dick Buxton

"We've operated this store thirty-eight years as of April 1, 2005." said Dick Buxton. "I didn't know anything about running a store and I learned to cut meat from a book. Now people come far and wide for it.

"My son is also a butcher. His wife helps out and so does my other son when he is not driving the school bus. We always have young girls behind the counter. Some are grandmothers now.

"We are dispatcher to the town rescue and fire department. 911 calls us first and we're always here because we live in back and only take Christmas Day off. We have a generator so we're in operation even if the power quits."

The seventy coyotes killed in the annual Hound Dog Hill Coyote Hunt are reported at Buxton's Store. Some blame the coyotes for the low number of deer taken by hunters in the past few years.

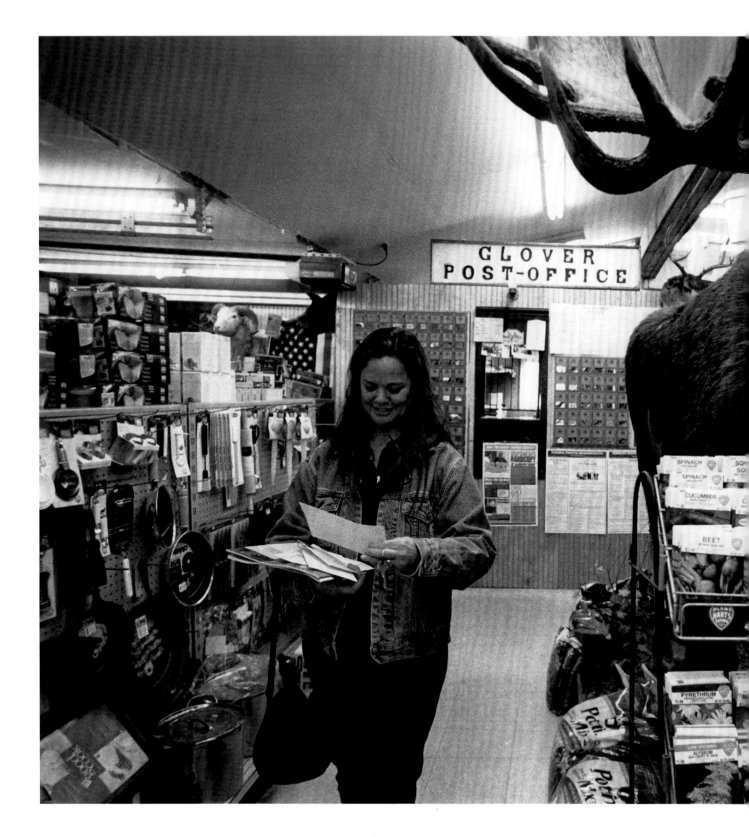

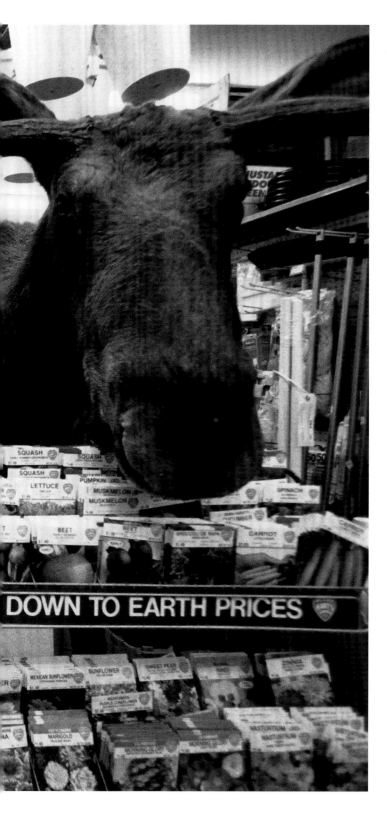

CURRIER'S QUALITY MARKET, GLOVER
James and Gloria Currier

Jim Currier has a passion for collecting stuffed trophies, so of course the store is filled with wolves, bear, deer, coyotes, martins, skunks, weasels, and other wild creatures he has collected during the thirty-five years he has been in business.

The store has a large sporting section of hunting and fishing equipment and a complete hardware section upstairs. It's easy to find things. Diapers are behind the wolf, and the post office is protected by the bull moose shot in Eden. Jim, his daughter Shari, and his son Jeff are all butchers and they are known widely for their prime cuts of Charolais beef.

DEBANVILLE'S GENERAL STORE, BLOOMFIELD
Darlene and Sherry Belknap

When Darlene and Sherry bought the store, they rebuilt it, moved and refurbished the gas tanks (under, heaven forbid, a canopy) and opened in 2004.

"We wanted it to blend in with the old buildings in town and not be a cookie cutter type of store. Whatever you need, we got it. We serve hot food to the snowmobilers in the winter, for their trail is just outside and, in the summer, canoeists stock up when they put in or take out from the Connecticut, which is across the road. Bikers come down from Canada on their way to Mount Washington and the summer people come in from Lake Maidstone."

They stock all the supplies locals need for fishing the ponds and the nearby Connecticut River, so pints of worms and cans of beer share the same space in the cooler.

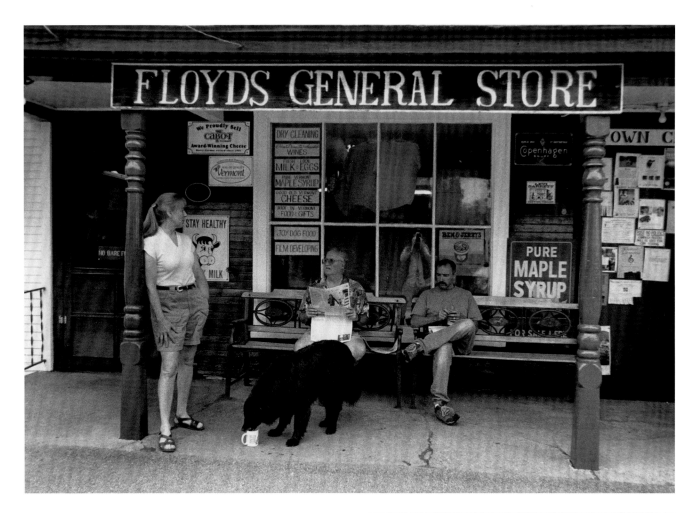

FLOYDS GENERAL STORE, RANDOLPH CENTER
Al and Jan Floyd

The store has been serving Randolph Center residents since 1845 and has been owned by the Floyd family since 1963. The town is the first home of the Morgan Horse, the Vermont state animal, and Vermont Technical College.

"We have the regulars come in every morning," said Al. "They sit around the stove and talk about deer herds, current topics such as the Morgan Horse Farm leaving the state, and of course politics. The group is more on the right than the left and sometimes the *New Yorker* cartoonist Ed Koren attends. He is on the left. He's okay.

"Politicians kept putting up campaign posters on my bulletin board and covering other messages. So I put up a sign saying any political posters would be used for cow bedding by the farmer down the road. That stopped it.

"The gas people came here and were going to put in new tanks and a canopy over the pumps. I told them no they weren't. I don't sell gas anymore and the old gas sign is still standing."

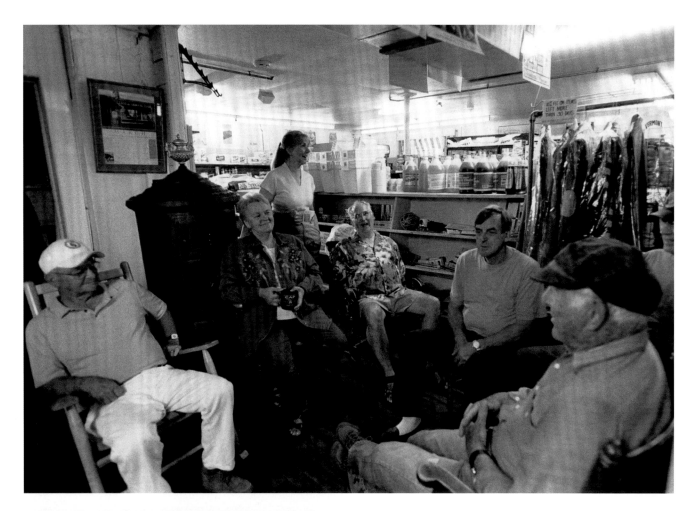

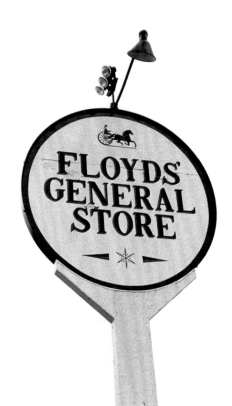

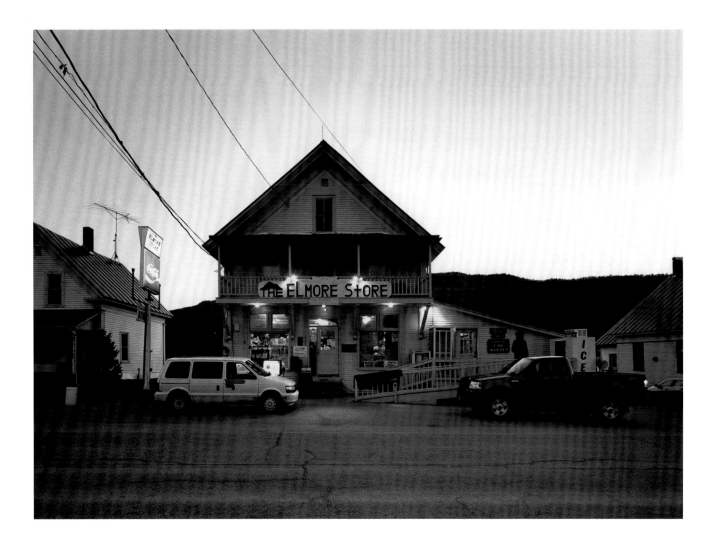

THE ELMORE STORE, ELMORE
Kathy and Warren Miller

The Millers are locals, from Elmore and Morrisville. Kathy's great-great-grandparents sold land for a dollar an acre to the state of Vermont for the Elmore State Forest. During the winter Kathy does double-time in the store and the post office as her husband is a representative in the state legislature.

"We have a quality of life a million dollars couldn't buy," she said. "One of the reasons is that a child can walk across the street to school, and the church is next to us. We have the lake and the mountains behind us. We sell gas to boaters and to cars. We sponsor the Elmore Fire Department Chicken Barbecue for the July 4th weekend.

"We're open seven days, ninety-six hours a week — closed only on Christmas — and my husband and I did that for nine years without help. Running a country store is like farming. You don't close the door and it gets in your blood; it's something you love to do."

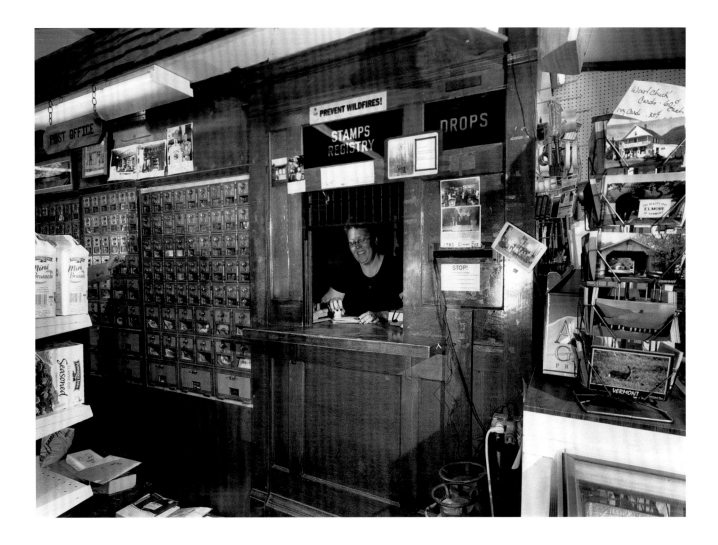

It used to be that Vermont country stores reserved a section for the post office. Now only a handful of stores are also post offices where the owners serve double duty as storekeeper and postmaster. The Elmore Store has 158 PO boxes; there are 750 residents, so most receive their mail by carrier. Kathy usually sorts the mail. She and her husband have PO Box 1 and their zip code, if you care to write, is 05657.

Barnard Country Store, Barnard
Carolyn DeCicco and Kim Furlong

The store is on the end of Silver Lake, across the road from the small grass beach, the focal point of Barnard, where in the 1930s Dorothy Thompson and Lewis Sinclair summered at their Twin Farms (now a super fancy hotel with a rate of more than $30,000 a night).

"We're the oldest continually operating country store in Vermont," said Carol. "We built up a gourmet deli business (tortellini salad, Hawaiian calzone) just to survive and it has changed our whole store. We serve breakfast and lunch and a guest chef prepares a special meal every Monday night. We've had a five-star chef from Twin Farms cook for some thirty people and for another dinner a part-owner of a Maine lobster boat flew in his catch.

"We have a good mix of people; there are local contractors, self-employed property managers (they mow the lawns) loggers, and trust funders. In the summer the kids are always over here at the soda fountain or reaching for a cone through the ice cream window." One of the favorite flavors is Moose Track (peanut butter, vanilla and chocolate). The large size cone is so big and decadent it gives tummy aches, for $2.50.

Harold Hays — everyone calls him Bucky — is ninety-two and every morning makes the coffee. He has worked for the store "since I don't remember when" and is proud of the forty years that he served as volunteer on the local fire department.

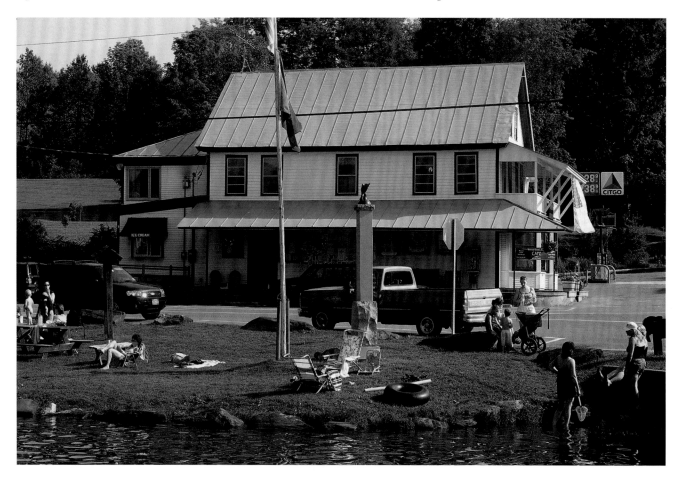

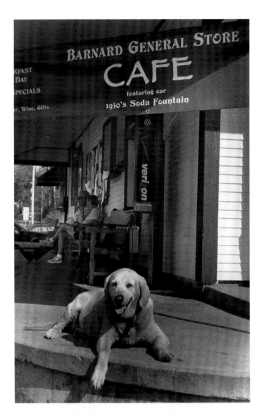

Many country stores have a canine greeter. This yellow lab's name is Lucy, and she often sleeps on the job. She's not supposed to go in the store, but she sneaks in, now and then.

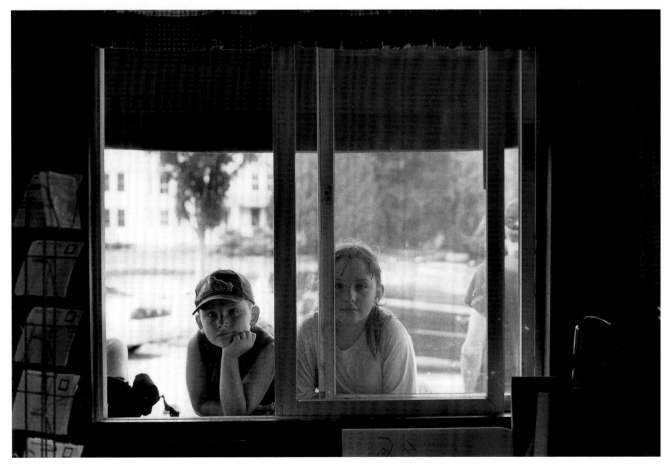

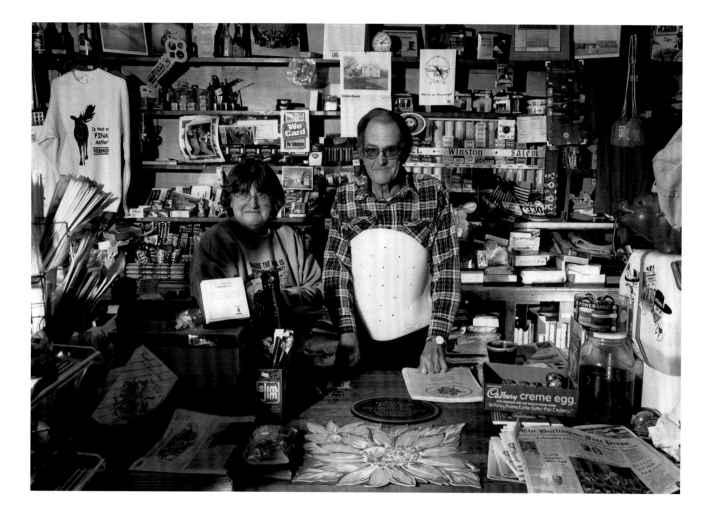

TALLMAN'S STORE, BELVIDERE CENTER
Hugh and Myrna Tallman

The store was built in 1906. Myrna's parents bought it in 1951, and she and her husband purchased the store from them in 1960.

"We're dinosaurs," she said of her country store. "Only seventy of us are left. Three years ago there were 117."

"We carry a bit of everything. If you need jar rings we got them. We sell cream drops for $2.49 a pound. They're $10 a pound in other country stores. We got flea powder and second-hand books.

"No, I don't have a computer. Don't need it. My husband and I will run it till we can't anymore. Then trot me out back with the jukebox and that 300-pound register we have.

"We run this store to have a good time and I always knew what the kids were doing and that's playing outside.

"We're open every day but I take off one day a year. I go to the opening of Thunder Road." ☘

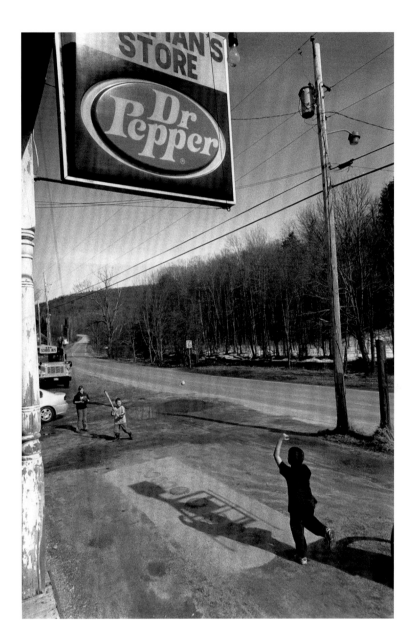

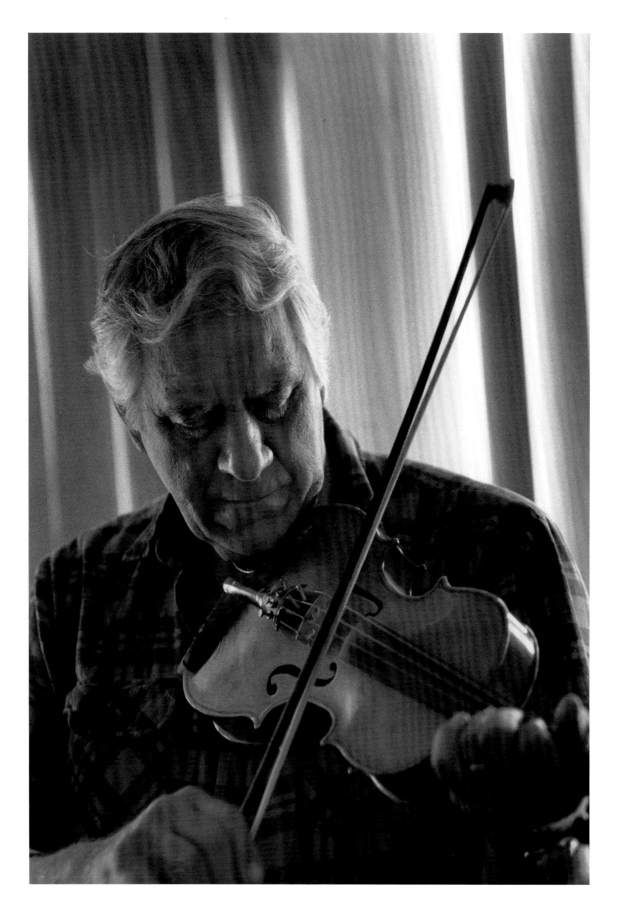

BOBBIN MILL RESTAURANT
Westfield

Paul Daniels and his wife, Nancy, have a beautiful farm in East Albany and raise Diamond Jubilee cows, a breed Paul developed by breeding a Dutch Belted dairy bull to Red Angus and Red South Devon beef cattle. That doesn't have much to do with fiddling, but let Paul tell how the Bobbin Mill Fiddlers came to be.

"I took up fiddling when I was sixty — ten years ago. I was then buying logs all around the area and got to know the fellas. I came up here to the Bobbin Mill Restaurant — they used to make bobbins here — for coffee one morning with Ron Sanville and Leon Couture.

"'You got your fiddles with you?' I asked.

"'Yep,' they said. 'In the car.'

"'Let's bring them in,' I said.

"'Oh, they wouldn't want us to play in here.'

"'Sure they would!'

"So they brought in the fiddles and the folks enjoyed them. This was on a Tuesday and we decided to come back the next week.

"When we came back a guy from the *Chronicle* newspaper in Barton was selling advertising and saw us playing. He took a picture and it ran in the paper. People started coming in to hear us and so did musicians. We evolved into the Wednesday morning Bobbin Mill Fiddlers.

"Come early. We start at about 7 A.M. and the place is packed."

Off and on there might be twenty or twenty-five musicians that play at the Bobbin Mill but usually not more than a dozen or so at a time. There are fiddlers

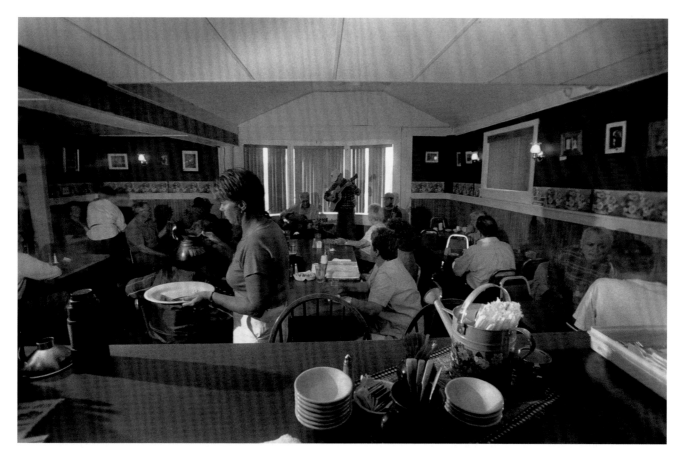

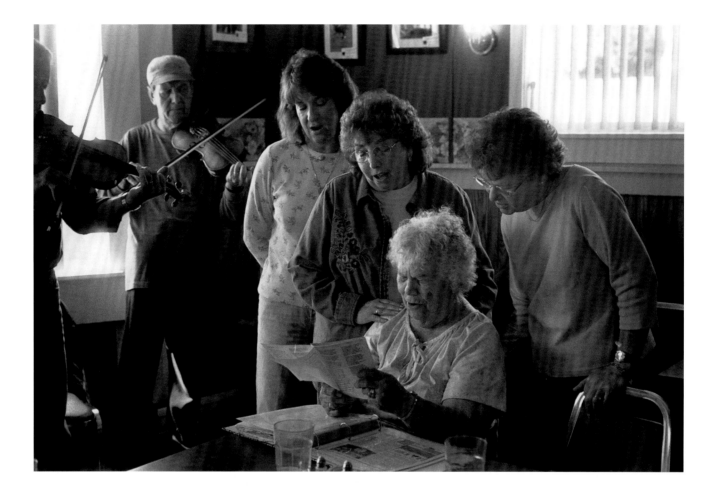

and guitar, dobro, banjo, and mandolin players, Some have dulcimers, or play the harmonica and they are singers. Millie Gaboriault is at the keyboard and her mother Eveline plays the harmonica. She is ninety-six.

"I keep the rhythm," said Millie. "Someone has to. We've been eight years playing. I play by ear; everyone plays by ear. We've no problems. We let the music take us where it goes. We have a good time. It keeps us young. Most of us are retired, sixty years old and on up. We also play at nursing homes. We enjoy it, and those people in the homes have nothing much to do or think about and they look forward to our music.

"You know, Channel 5 came up from Boston and did a show on us."

"Most fiddlers," said mandolin player Lawrence Earle, "learned from their fathers and grandfathers, and it was all French Canadian. Well, Burt Porter plays Celtic. I learned the fiddle when I was thirty years old. I became real good, but then I mangled my hand. I didn't play for eighteen years until the Bobbin Mill group started. I can't play the fiddle but I can the mandolin.

"The best of all fiddlers was Leon Couture, who helped start the group. He passed away."

One morning a car with a New Jersey plates stopped in at the Bobbin Mill. It contained a couple and a child. He was looking for a place to eat breakfast and asked why all the cars were here.

"Good music!" I said.

He went in to check it out and was back in his car in 30 seconds. "A bunch of music players." he said to his wife. "Let's find some other place," and he drove off. ❦

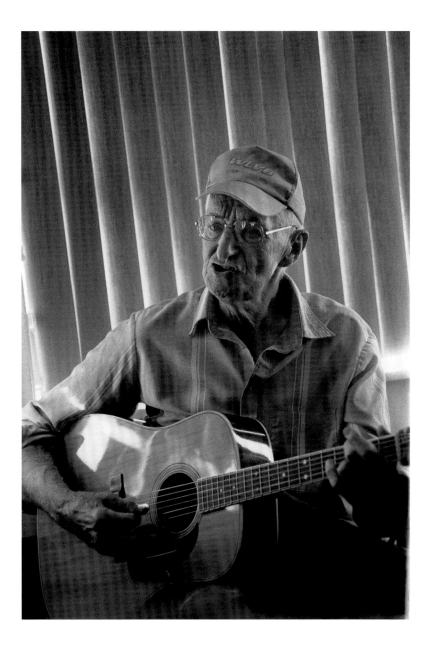

Take a walk at dusk down Granite Street in Barre. On the left is a somber, two-story redbrick building trimmed in granite known locally as the Old Labor Hall. Stop in front of it and look at the darkened building. There's energy within, echoes of union meetings, political rallies, dances, dinners, plays and musical events, boxing matches, a co-op store (opened in 1901, Vermont's first, we believe) — all of it distilled with resolve, joy, pride, anger, and yes, even murder. It is perhaps the only building in Vermont built by sweat and toil as an image to solidarity of the working class, in this case the granite cutters, carvers, and polishers that immigrated from Carrara, Brera, and Milan, Italy, to work in the quarries and sheds that surround Barre.

These immigrants were the bottom rung of a two-tiered society — one of wealth that owned the factories, the other of poverty, workers who labored ten-hour, six-day work weeks at low wages and lived under a repressive system of prejudice, regulation, police, and court.

The Barre Italians organized and in 1900 built a symbol of their resolve— the Socialist Labor Party Hall. What these Italians believed in, and wanted, was a decent wage and a shorter work week, education for their children, equal civil and political rights, and guaranteed care in case of sickness or accident, in times of unemployment and old age — all the benefits Americans gained a third of a century later and are still forced to fight for.

The Socialist Labor Party Hall held emotional and uproarious meetings, including a 1903 gathering of Socialists and Anarchists during which, in a scuffle between the opposing parties, a bullet (a ricochet, they say) struck and killed thirty-four-year old stonecutter Elia Corti. In 1912, the site also served as a refuge for thirty-five children who were sent to Barre from Lawrence, Massachusetts when the Bread and Roses textile worker's strike there turned deadly. The underfed and scared children of the striking workers were met at the hall by hundreds of Italian-American Barre residents, a band, and a huge buffet meal. After being examined by local doctors and eating their fill, the children went home

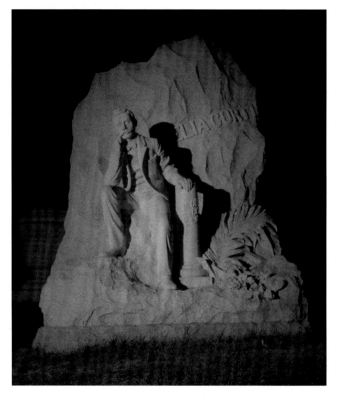

The full-length sculpture of the murdered Elia Corti is just one of the remarkable tombstones and memorials in the Hope Cemetery, all created by Barre's artisans. This monument was sculpted by Corti's brother and brother-in-law. The slain labor activist wears the bow tie that was the badge of the anarchists.

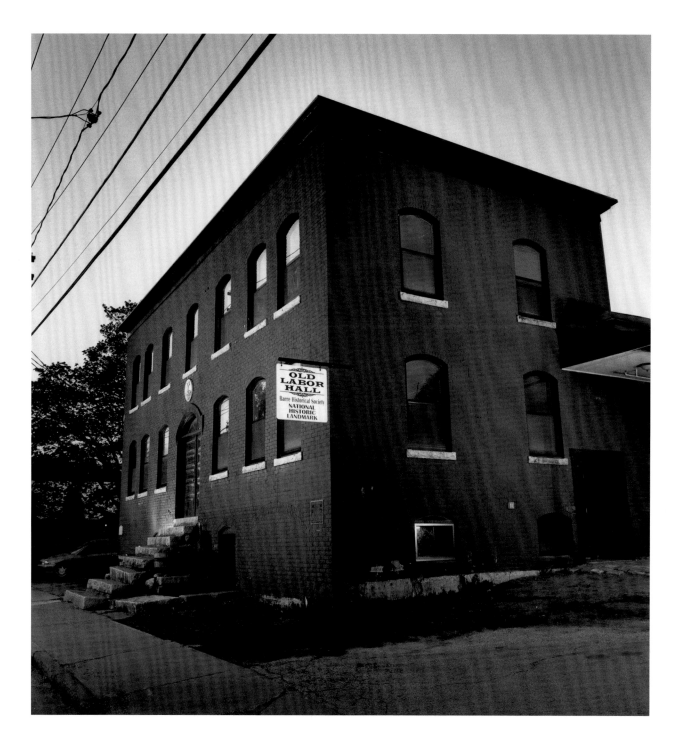

with Barre families, where they were cared for until it was safe to return home to Lawrence.

After World War I a national tide of "patriotism" targeted recent immigrants, socialists, anarchists, communists, and any other group that was not then allowed in the social fabric of America. False arrests, deportations, beatings, and murders followed. The arrests in 1927 of Nicola Sacco and Bartolomeo Vanzetti, a fish peddler and shoemaker wrongly accused of murder, raised protests around the world and led members of the labor hall to hold fundraisers for Sacco and Vanzetti's legal defense. Later, after the two men's conviction and execution, many Barre families traveled to Massachusetts for their funerals.

Coupled with the Depression, the hostile and dangerous social and political climate forced many members out of the Socialist Labor Movement, and in 1936 the hall was closed and sold to a produce company, which used it as a warehouse. The company went bankrupt in 1994, and the bank sent to the dump all the historical records from the Labor club.

The building would probably have been torn down if it weren't for the Barre Historical Society, which organized an extensive fundraising campaign through unions and other associations. They bought the building, repaired it, and again the hall resonates with community dinners, conferences, classes, wedding receptions, and other events. ❧

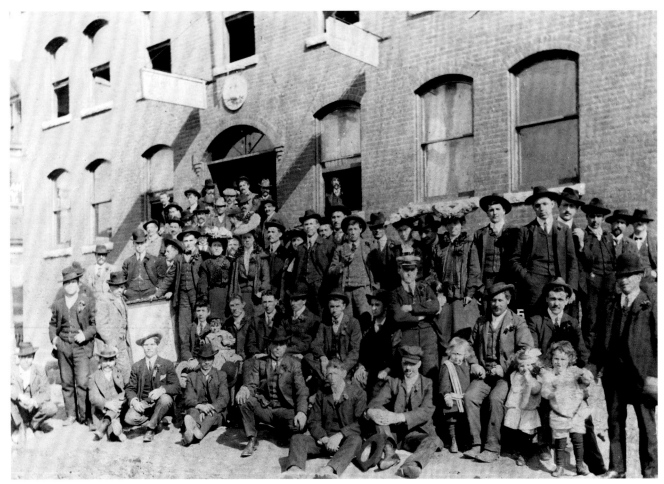

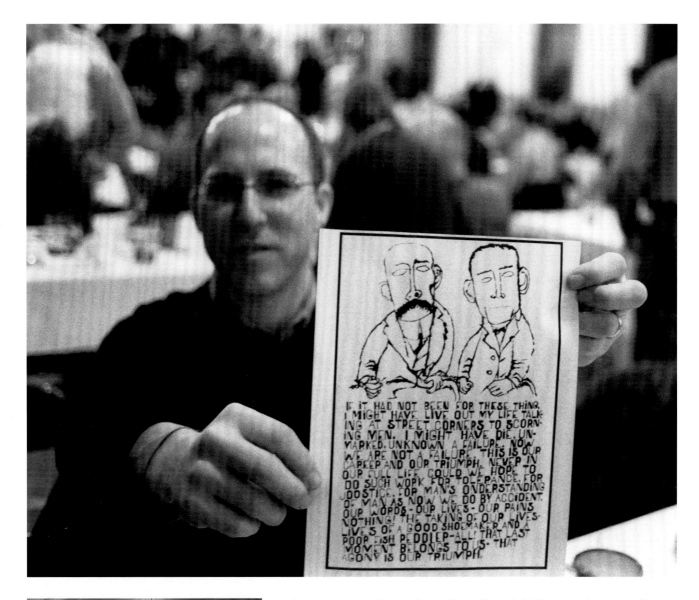

The Barre Historical Society hosts a dinner (home-baked lasagna and spumoni, of course) in memory of Sacco and Vanzetti. Historian Michael M. Topp gave a lecture based on his new book, "The Sacco and Vanzetti Case" and filmmaker Peter Miller (above, no relation to the author) showed his documentary film about the famous trial. He holds a flyer with a quotation from Mr. Vanzetti shortly before he was executed. Guest of honor was former Governor Phil Hoff (seated left), a Democrat whose election in 1962 broke a century of Republican Party rule in Vermont. It reads:

> If it had not been for these thing, I might have live out my life talking at street corners to scorning men. I might have die, unmarked, unknown, a failure. Now we are not a failure. This is our career and our triumph. Never in our full life could we hope to do such work for tolerance, for joostice, for man's onderstanding of man as now we do by accident. Our words — our lives — our pains Nothing! The taking of our lives — lives of a good shoemaker and a poor fish peddler — All! That last moment belongs to us— that agony is our triumph.

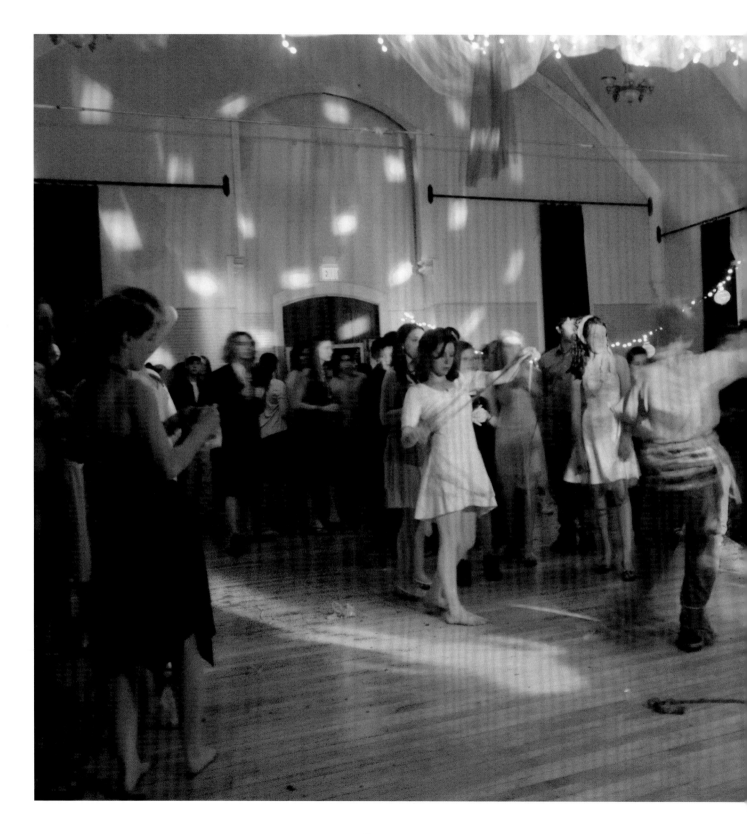

Annual Semi-formal Teen Dance
Putney

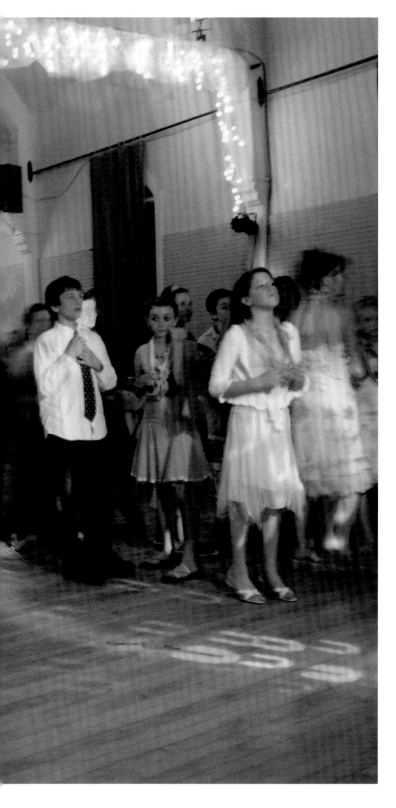

They call it the Annual Semi-formal Teen Dance but it's really Putney's middle-school prom, when sixth- through ninth-graders from Putney, Dummerston, and Westminster dress up and celebrate the end of the school year. The ninth-graders are moving on to high school in another town and the dance helps mark the transition.

They and their chaperones — there are lots of chaperones — arrive a half hour early at the Putney Community Center, a converted church in town. The girls are fabulously attired in dresses bought, borrowed, and "put together." Some have on their mothers' high-heels. They have wrist corsages and some carry a single rose. The corsages are the gift of the chaperones, for very few of these kids come with a date. Remember, this age is that uneasy time when the opposite sexes are just beginning to take a closer look at each other.

The boys are dressed more informally, although a few wear jacket and tie. Most are shorter than the girls. Maybe it's the high heels. The boys appear more nervous — huddled together, telling jokes, horseplaying. The girls are primping and writing messages in their girl-friends' memory books. Two are blowing bubbles. There's a lot of jittery laughter in this crowd, a lot of sweaty palms being dried on pant legs, and even a little crying in the girls' bathroom. There's energy in these kids; they just don't know where to focus it.

When the music starts, many of the girls dance together while the boys look on from the circles they've formed along the perimeter of the room. They don't know quite what to make of those girls they went to school with that are morphing into something alluring, beautiful, and incomprehensible. When there is a call for a group dance, all line up symmetry emerges between the

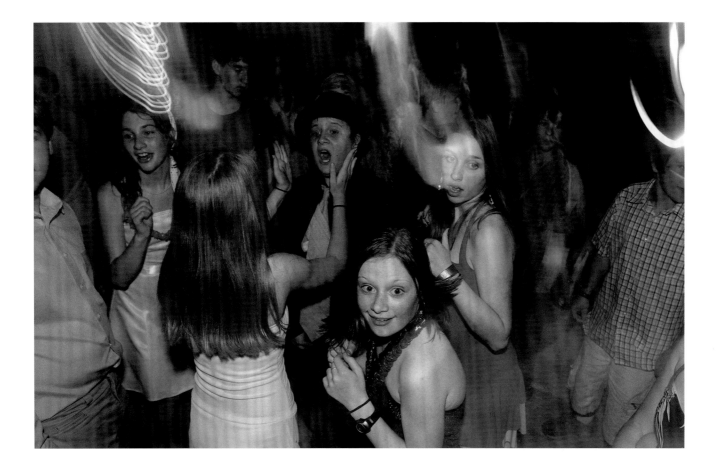

boys and girls. During the slow dances, some of the boys have that look, "What am I doing here? What do I say? Why am I holding this girl? I like it but I don't . . . When will this dance end?" Most of the girls display poise and sophistication that appears a couple of years advanced from their male schoolmates.

In a side room the kids have made a backdrop of cloth and drapery and the chaperones, most of them parents, are busy taking photographs of couples and groups. The photos will go into memory books and family albums and will become part of the visual record of a coming-of-age ritual.

Other parents and relatives drop in later to watch. Some attended dances in the Community Hall in their own youth — dances that they remember because of a special date, or because they were going to college, or into the military.

The dance ends at 10 PM, and the cars of parents and relatives are lined up outside waiting to drive these kids home. It's been a frenetic, giddy, happy evening, a goodbye to all that . . . childhood. ❧

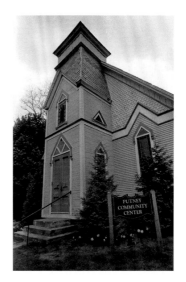

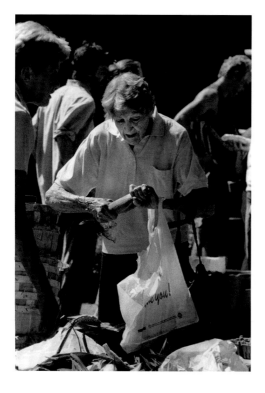

"People thought that the sellers were mostly hippies, spreading out bug-eaten veggies on the ground," was Janet Bailey's memory of her first day of selling vegetables, in 1979, at the Brattleboro Farmer's Market.

"On that first day we sold a bushel of spinach. I joined the board, and by the end of the season the eight of us who were selling had grossed twelve thousand dollars. We were close to extinction. "

Now the Brattleboro Market is robust; in 2004, thirty-nine vendors sold $400,000 of product: home-grown vegetables, flowers, fruit, herbs, home-raised beef, lamb, and pork, eggs, pies, preserves, crafts, and Thai, Indian, and Yankee meals prepared at the market. This is a cheerful gathering place, freshened by a brook and shaded by trees. Musicians play in the center of the market and children often dance around them. There are tables where people can sit and talk, have lunch or braid their children's hair. It is a relaxed gathering of people who have come to share the afternoon. A celebration, you could call it.

When I was there in September, the display counters blushed with pints of raspberries and crates of Macs with that freshly-picked tang that is so much part of Vermont's fall; there was a wagonful of sweet corn and a wide selection of tomatoes and melons, leeks, pearl onions, flowers, fresh lamb, and recently bottled honey. It was . . . succulently decadent. This is a celebration, and when locals come to buy the best produce grown in the

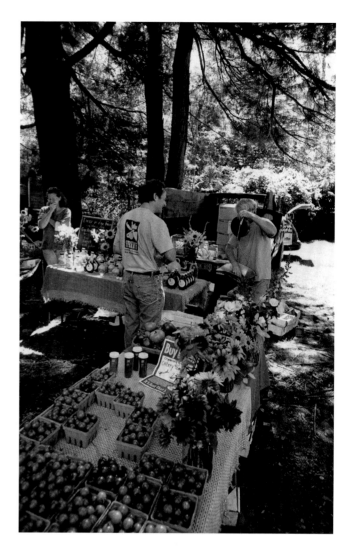

Brattleboro region, it goes without saying that, in such pleasant surroundings, they are going to eat well and meet their old and new neighbors. People are so relaxed and at ease they don't want to leave.

"And that's a problem," said Janet. "There is not enough parking space for other buyers."

This year there are fifty-six farmer's markets in Vermont selling fresh produce and crafts to their neighbors. Nationally there are now more than 3,700 markets, representing 20,000 farms, that attract one million buyers.

The concept of selling locally with no middlemen hasn't changed much since a farmer's market opened in 3500 B.C. in Uruk (read Iraq), in Mesopotamia. It wasn't until A.D. 1634 that America's first market opened in Boston.

"I joined the board just when an interest in organic food was starting and we had to woo customers," Janet said. She's a small, pretty woman with a warm smile shaded by her cap. This was her twenty-fifth year of selling veggies and eggs at the market.

"We didn't know how to meet the public and were so inexperienced that we wouldn't bring enough produce, so all the corn or carrots would be sold by midmorning. As we became more savvy, the community of Brattleboro gave us support and we now have a board manager to oversee our group, the Brattleboro Area Farmers' Market.

Each Saturday between May and October, five- to eight hundred people gather at the market, and these buyers are not looking for the organic seal.

"We never required our sellers to grow organic," said Janet, "and most of us are not certified, because it is expensive and takes lots of paperwork. We don't need a certificate to tell us we are organic. Our customers know us and our farm, and we tell them what our practices are. Legally, we cannot use the term 'organic.' We like to call our produce Morganic. Others call it Verganic."

What these farmers are doing, say the analysts, is offering decentralized marketing as an alternative to big box bagging. What the farmer's markets are also doing is circulating money locally, providing very fresh food, and making their communities that much richer. ❧

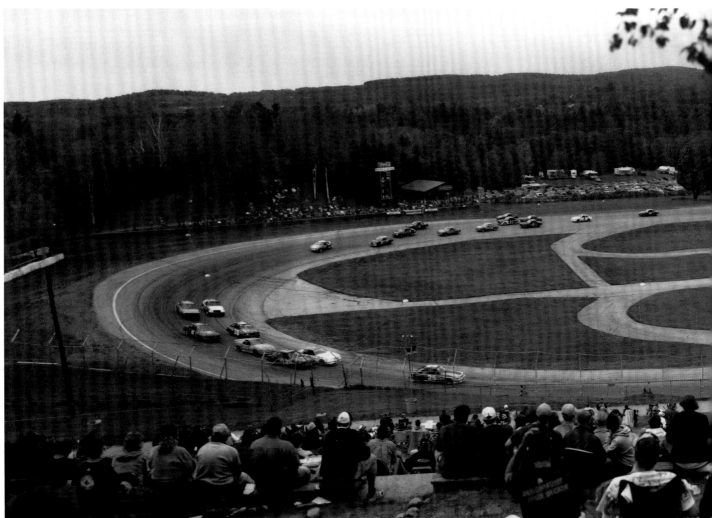

THUNDER ROAD INTERNATIONAL SPEEDBOWL
Barre

Thunder Road is Vermont's greatest gathering spot," said Tom Curley. "It has sustained Vermonters for 40-some-odd years."

Consider him partial, because he is co-owner, along with Ken Squier, of the asphalt-paved, quarter mile stock car speedbowl in Barre, but he's probably right. Since 1960 the speedbowl has brought together raw novices and savvy pros to race their stock cars in front of up to ten thousand fans, some of whom have never missed a race. When Thunder Road begins thundering on the first weekend of May, you know summer's here.

Stock car racing is well suited to Vermont's woodchuck personality, says Ken Squier, who spent twenty years as CBS's senior motor sports editor and announcer and is known nationally as the voice of stock car racing.

"You need courage, because the sport is dangerous. You need good eye and hand coordination, and you have to be smart. And those who learn to race well have patience — they build a rhythm on the track and hold and hold and learn to lift the foot off the pedal when it can win the race. Sometimes it is a one-hundredth of a second that makes a winner.

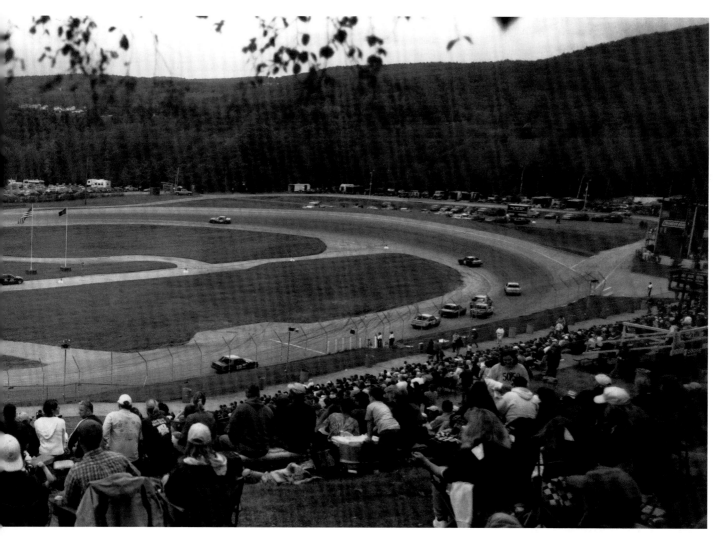

"It's a very democratic sport. This is no school-financed program. The racers start with nothing and build up. Kids get a driver's license and their fathers help them work on their cars. They have no time to get in trouble as they are under the hood in the garage. Eventually these young racers find a sponsor and race in the entry level. In about seven years they make a good driver. We have father-and-son and mother-and-daughter race teams. It's a family thing, with fans and with racers, and it becomes a passion."

About half the fans at Thunder Road are keen about the sport and know when a racer is pushing or loose. The other half are hoping for a spectacular accident — lots of banging, fire, and smoke. In the stands are families, friends, and babies in strollers. Above the stand on the left are crew members in radio contact with the racers. To the right is Bud Hill, where the picnickers lie about. Some mimic the spreads seen at Mozart festivals; others live up to the name of the hill and suck on a can of beer and a cigarette. There's a great view to the northwest of the Green Mountains, but what captures the attention is the short, oval track with its growling whine and the quick moves a racer makes to pinch the guy on the inside as he works the geometry of the track. Many in the stands have been racers or have a son or daughter or friend who is racing — you can tell by their

reactions to what is happening below. After the race, fans and racers mingle in the pits. Thunder Road is democratic and thank god not politically correct.

The sport of stock car racing was given a boost at the end of World War II. There was a surplus of used, beat-up cars, gasoline rationing had ended, and the veterans were home. "Do you think a veteran who had been using a flame thrower on Okinawa wanted to settle down and play softball?" asked Ken. "They wanted noise and action. They knew mechanics, loved the idea of competing, and were no stranger to adrenaline."

Vermont had twenty-two dirt tracks in the late forties and fifties. There was always a new idea taking tangible form in the garage. The first roll bar was constructed of wood taken from a four-poster bed. Football helmets were the only protective headgear available. Model A Fords were one of the favorite country cars to race, because there were so many of them. Racetracks were where young Vermonters hung out.

As the sport grew, though, it became expensive. Racing teams with money bought fancy engines, extra tires, and shock systems, swamping the wildcatter.

Thunder Road put the stock back in stock car racing, and kept the costs down. Much of the credit for this is due to Tom Curley, who makes the events run smooth and safe. He instituted a rule that all tires had to be of

one brand, one style, and he put a limit on how many tires a racer could use during one competition. Then he decreed that all race cars at the mid and top level had to have crate engines (which cost up to $14,000 less than non-crate engines) so no one racer with deep pockets could purchase an unfair advantage. Now there is a new rule for the type of shocks that can be used. These regulations have kept up the enthusiasm of the down-home boy or girl who knows the playing field is level and the costs constrained and they have a chance to reach the top. As a result, the speedbowl has changed small track racing, actually invigorated it, and brought in more racers and fans.

This year Thunder Road is having one race in which all cars are required to use a mixture of gasoline and ethanol. "We want to make a statement," said Ken, "that if stock cars can race on this mixture, then you can drive on it."

Thunder Road holds races on nineteen days each summer, every Thursday night and Sunday afternoon, and ends the season with the Milk Bowl Race in October, where the winner has to kiss one of Anne Burke's prize Ayrshire cows. On any given race day, up to 10,000 fans will gather to watch more than 120 racers compete in sixteen to eighteen events, driving everything from sorry looking pickups to fine-tuned Camaros. After NFL football, stock car racing is the nation's largest spectator sport, and at Thunder Road, it is most often a family affair with deep roots. ❧

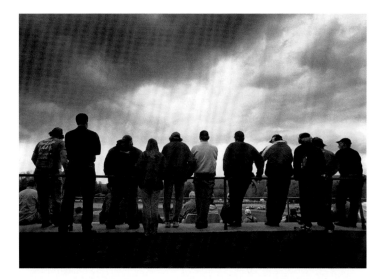

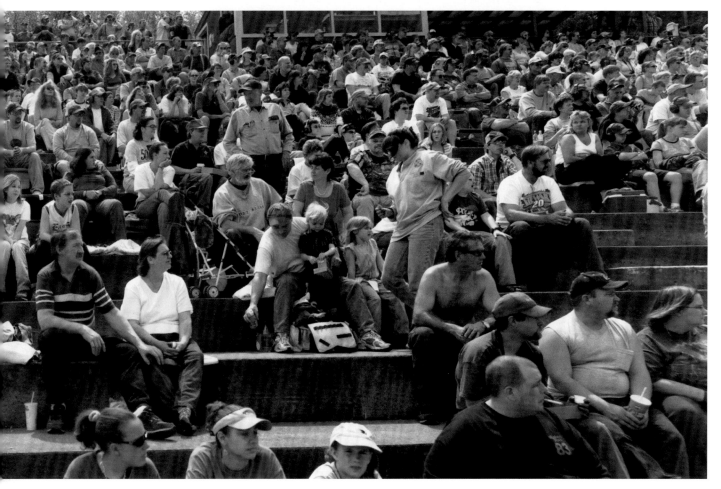

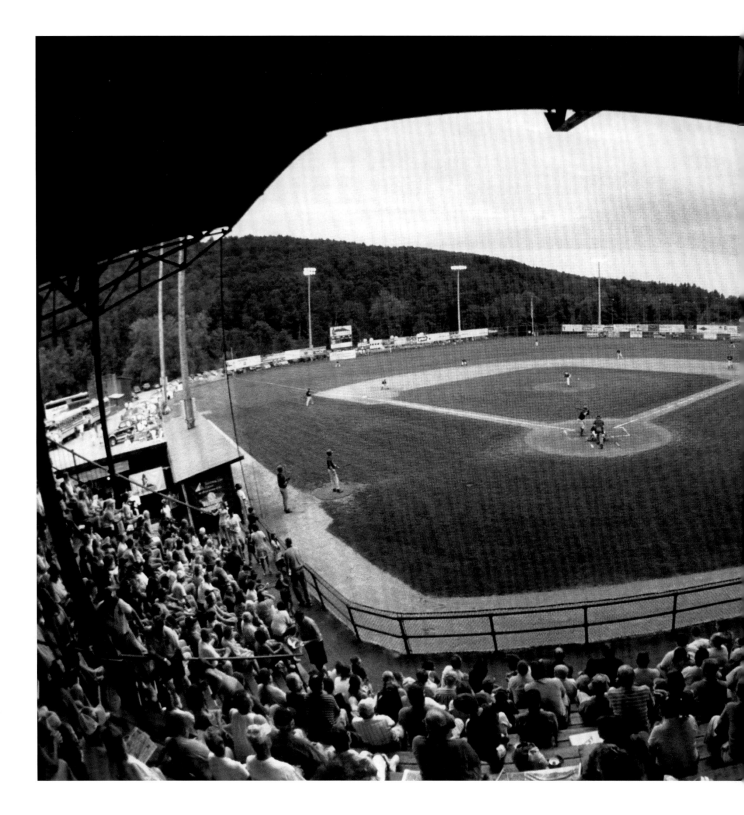

THE VERMONT MOUNTAINEERS BASEBALL FIELD
Montpelier

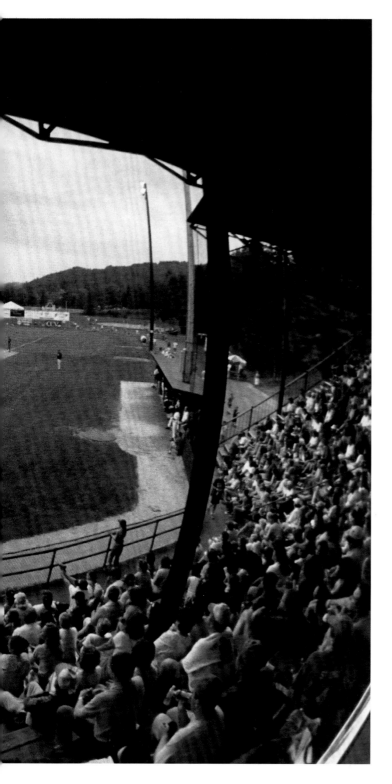

The people of Montpelier—*Montpeculiar* is the city's irreverent nickname — had the blahs. Politics oozing out of the state house were too embroiling and the state's dominance as an employer was not empowering. So what could be better to perk up this town than to host their very own baseball team?

The history was there. Beginning in 1887, Montpelier was home to its own semi pro and collegiate team (which, during Prohibition, was often a front for rum-running). The team was so popular that in 1935 the federal government built the Montpelier Recreation Center and constructed bleachers, a baseball field, and installed lights.

For seventeen years the 1,200-person-capacity bleachers were filled with fans watching first the Montpelier Senators and then the Twin City Trojans. The league closed in 1952, after officials banned college players from being paid.

In 2001 a local group drummed up interest in fielding a baseball team that would play under the New England Collegiate Baseball League. The idea took and, after some hardcore fundraising and promotion, Montpelier won a franchise. The capital city immediately drew together to support the team. Sponsors were found, money raised, coaches hired, and players recruited from thirteen states and Canada. The name of the team — Vermont Mountaineers — was selected through a contest. A mascot, appropriately a woodchuck, was created and named Skip, after an early supporter of the team who had died. On June 7, 2003, the Vermont Mountaineers played the first of a forty-two-game schedule.

Going to a Mountaineers' game is a delight. The field is in beautiful shape with new lights and renovated bleachers. A typical game begins with Skip the

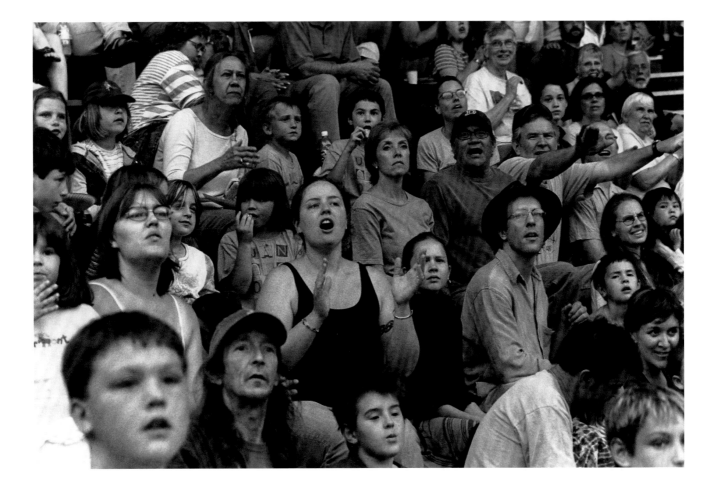

woodchuck playing with the kids and ballplayers signing autographs. Seventeen hundred fans mill in and around the bleachers. Kids from local little league teams run out onto the infield with the players during the pre-game introductions. Between innings, along the first and third baselines, there are kids' games, such as spin the bat and water balloon tosses — Skip officiates. When a foul ball is hit, the sound system lets out with the crash of breaking glass. In the stands the fans cheer, stomp, boo, and do the seventh-inning stretch with a sing-a-long. Families with babies, kids who are baseball crazy, serious fans with scorecards, and grandparents — just about everyone has a smile on his or her face, except when razzing the visiting team or the ump. In a way, it is not so much who wins as it is about having fun while supporting the home team. In fact, the people are so supportive of the team and its players that the Vermont Mountaineers is the first pick of many collegiate players. The young men stay with local host families, and many find work between games coaching baseball camps at the recreation field or at Montpelier businesses. Some enjoy the experience so much they return to visit their host families during holidays.

Now, back to the game. Sixteen Mountaineers have signed contracts with the big leagues. In 2005 the team won its division, and finished second in the NECBL championships, losing to Newport, Rhode Island in the final series. An impressive season for a three-year old franchise. Well, it would be nice to be champions and they will, they will.

Oh, we'll root, root, root for the Home Team
And if they don't win it's a shame
For it's one-two-three strikes you're out
At the old Ball Game. ❧

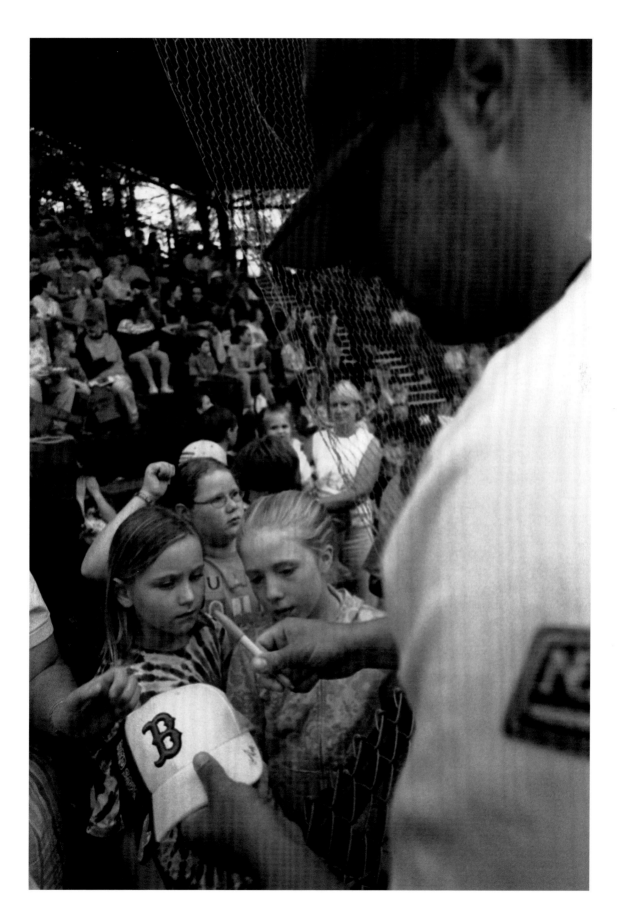

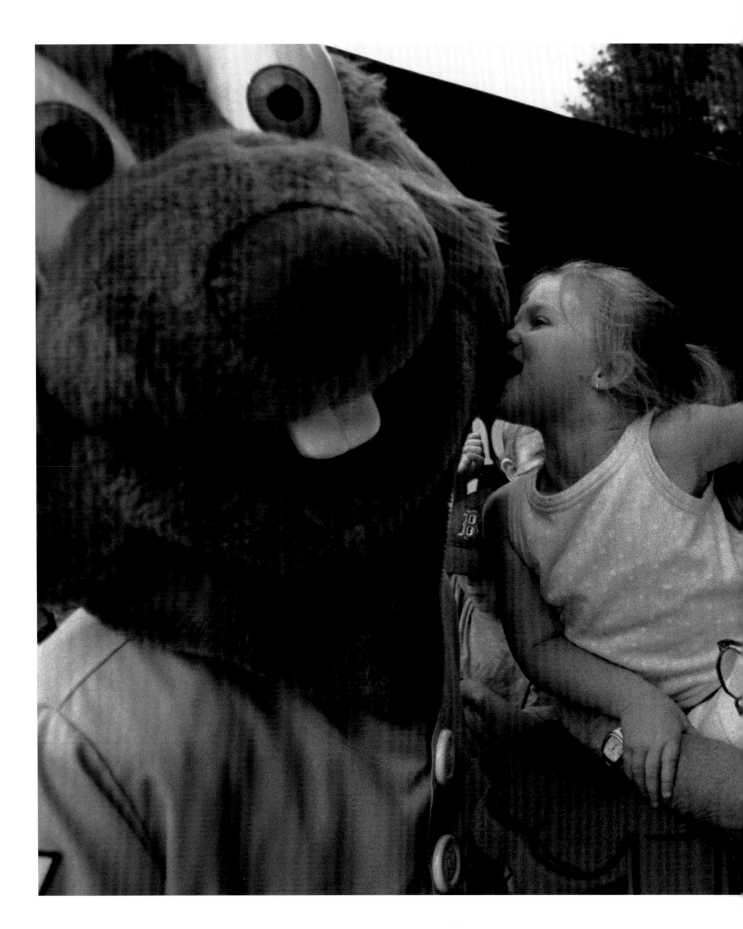

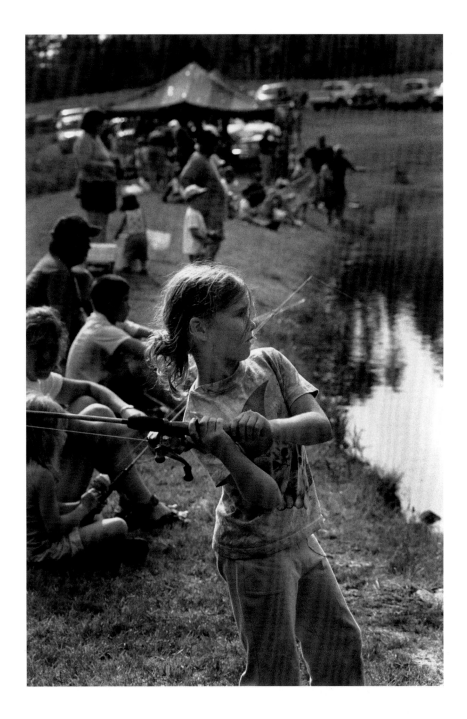

Lyford Pond is on the low side of a ten-acre upland field in Chelsea, at the end of Hall Road. To the west is a stand of pines that is a woodcock and grouse cover. On the high side of the field, to the north, is a small cornfield that the landowner, Dick Lyford planted for the wildlife—moose, deer, bear, raccoon, turkey, fox, and coyote have been seen on the property. Surrounding the field east and south are rolling hills covered with hardwood. You can't see a single house from this field — not a sign of habitation. On clear nights the stars shine bright; there is no light noise in this sky.

Lyford Pond is about a three-quarters of an acre, fed by a stream and by five springs under the surface. Cold water is what brook trout thrive in, and the pond is loaded with them.

It's here at Lyford Pond that the Chelsea Fish and Game Club hold its annual kids' fishing derby, which it has sponsored since 1960. A tent is put up for a barbecue, and this year forty-two kids came loaded down with rods, bobbers and cans of worms. You could tell by the looks on their faces that they knew there was going to be some good fishing here today. The week before the derby the Vermont Fish and Wildlife Department dumped 125 trout dumped into the pond.

One of the club members blew a whistle and there was a Le Mans start as kids ran to their banks and threw in

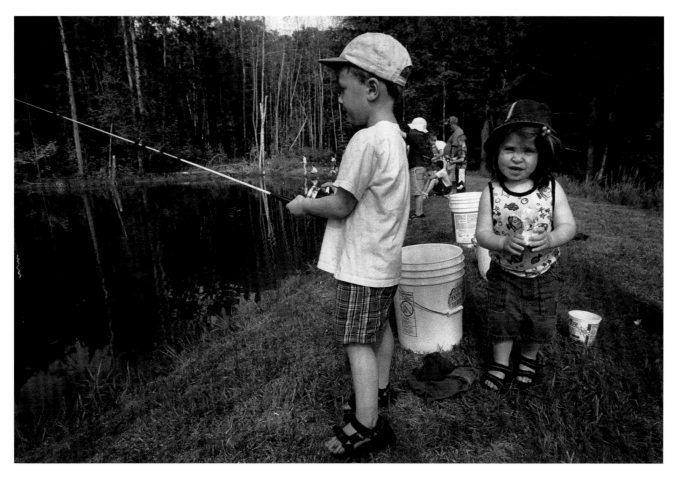

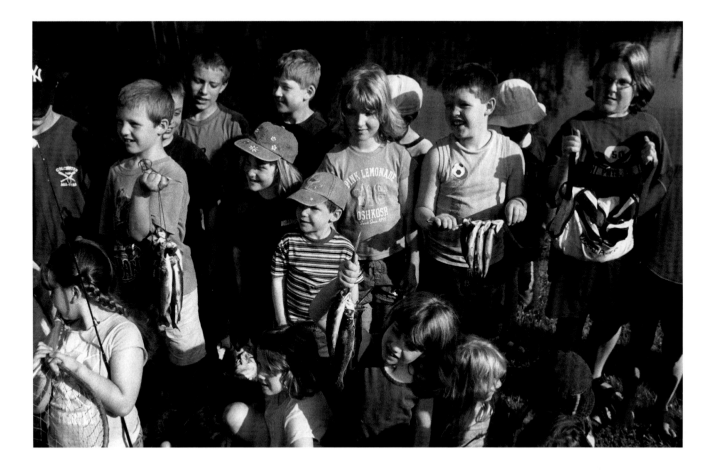

their lines. Almost instantly the bobbers were jiggling and trout were being reeled in, kids were gleefully shouting and parents were just aching to help.

Throughout Vermont there are more than sixty kids' fishing derbies held each year Many are sponsored by local fish and game clubs, which are members of the Vermont Federation of Sportsmen's Clubs. Organized in 1875 the VFSC helped found the Vermont Fish and Wildlife Department. Membership is growing in the clubs even though hunting and fishing license sales are declining.

At this year's fishing derby the biggest fish caught was a two-pound brown but most were brookies of good eating size. Nineteen boys and twenty-three girls were entered in the contest and they caught a total of 106 fish.

"The fishing derby used to be 90 percent boys but now there are more girls," said the host, Dick Lyford. "It's been that way for a couple of years. Don't know why."

At the end of the derby, after the kids demolished the hamburgers and hot dogs and went home with their strings of fish (usually the parents did the cleaning) members of the Chelsea Fish and Game Club collected under the tent. As the sun touched the hillside they sampled grilled venison and smoked bear, swapped jokes, talked about their latest outdoor ventures, and relaxed with their neighbors and friends, who, like them, enjoy Vermont's traditions of hunting and fishing. ❧

Dick Lyford (above) in story-telling mode. His pond adjoins the old Lyford farm in Chelsea, run for years by Dick's father, the late George Lyford. George was the star of "Nosey Parker," the movie made by John O'Brien.

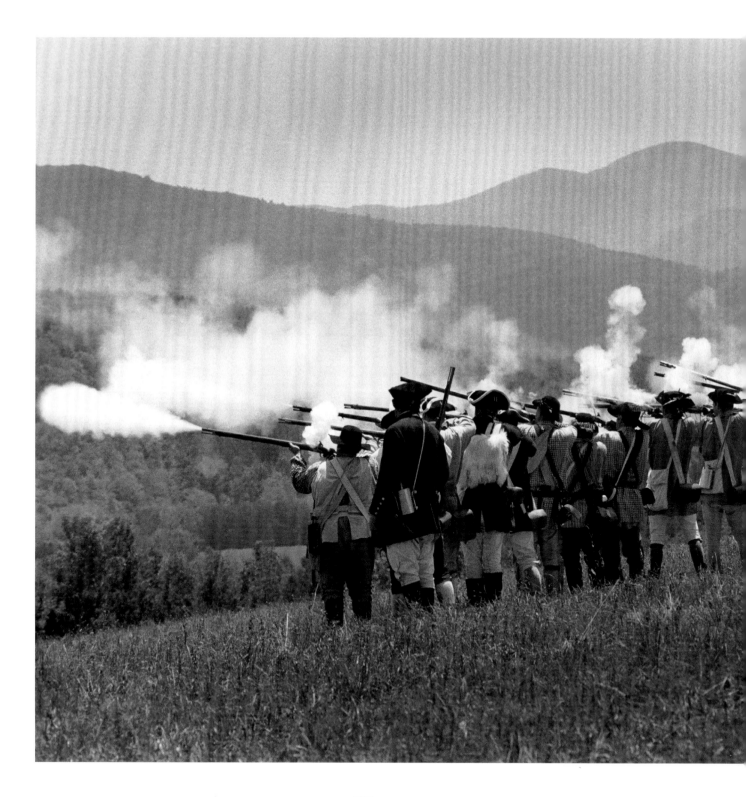

HUBBARDTON BATTLEFIELD
Hubbardton

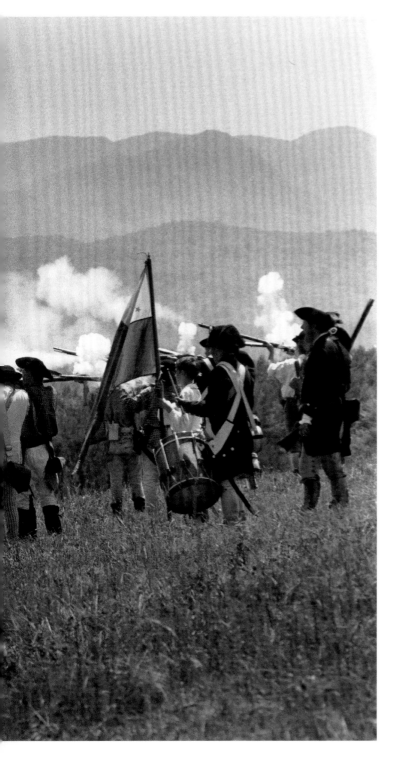

There is a beautiful 360-degree view from the stone wall at the crest of Monument Hill at the Hubbardton Battlefield. Beautiful now — there's almost always a breeze — but it was a killing field on a hot summer day during the American Revolution.

Seth Warner's Green Mountain Boys were hidden by the stone wall and fallen trees as they fired at advancing British troops. Musket smoke hovered over the hill. Seth Warner's Vermonters, the 2nd New Hampshire Regiment, and the Massachusetts Militia under Colonel Ebenezer Francis were ordered to engage and delay the 1,050 British and German troops detached from General Burgoyne's army. They were pursuing the American troops, who were retreating from Mount Independence and Fort Ticonderoga and heading to Castleton.

One hundred and one American, British, and German troops were killed that day, their bodies sprinkled over the field now so carefully maintained by the Vermont Division for Historic Preservation. The Brits won the battle, but the American's rearguard action halted their pursuit of the larger British Army and stopped Burgoyne's plans to contain New England. Three months later he surrendered his eight thousand troops at Saratoga. So the battle was a success, although the 234 Americans taken prisoner might have thought otherwise.

Every year, members of the Living History Association join with the Vermont Division of Historic Preservation

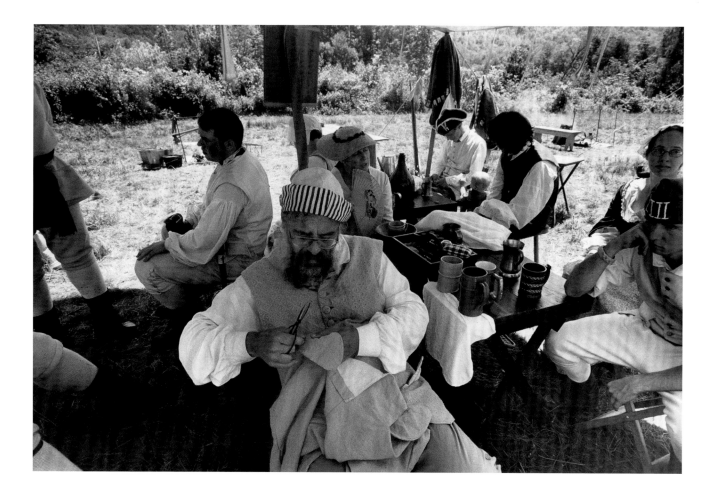

to reenact Vermont battles at Bennington and Hubbardton. Members dress as British, American, or German troops, equip themselves with muskets, and are fastidious in re-creating the battle scene and military movements. They set up tents and cook over fires with pots as they did during the Revolution (well, they use Aunt Jemima pancake mix).

"This is the best," said one participant, dressed as a redcoat. "No noise, no buildings, no new roads. You can feel this battle. Smell it. We are on a battlefield unchanged since soldiers were killed here."

The purpose of all this is to educate Americans about history, not only by reenacting battles but also re-creating the way of life of soldiers and civilians. The Living History Association believes an authentic reenactment is the best way to have their members share historical knowledge with an audience. Over ten thousand people see their interpretive shows and educational workshops every year. Several thousand usually show up for the Hubbardton reenactment, which is recognized by authorities as one of the best in the nation for its authenticity. ❧

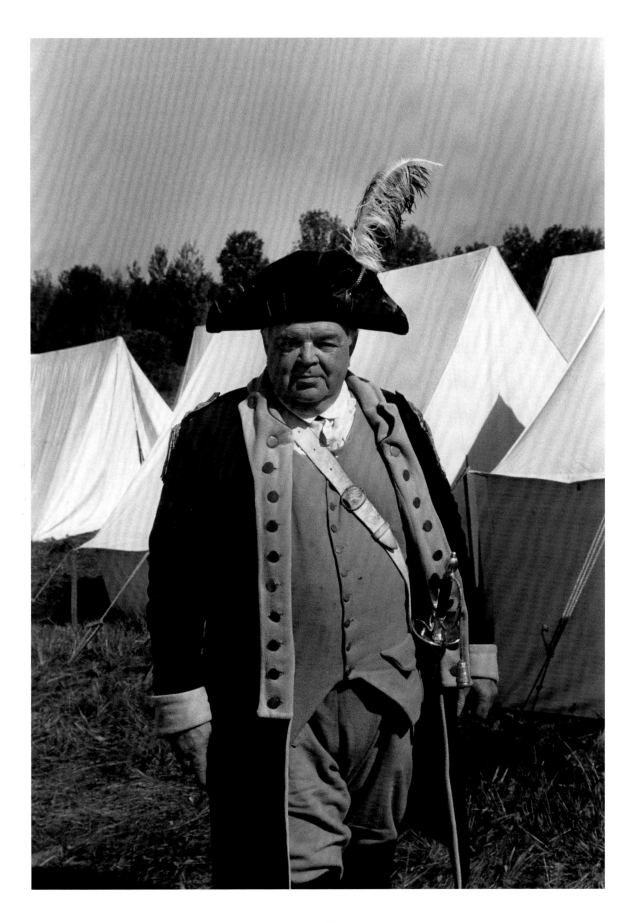

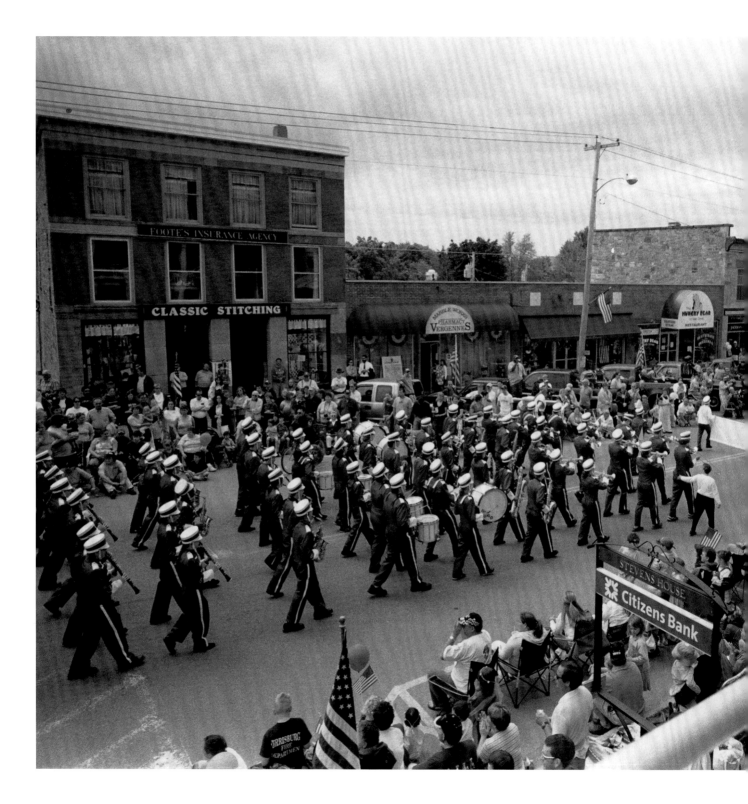

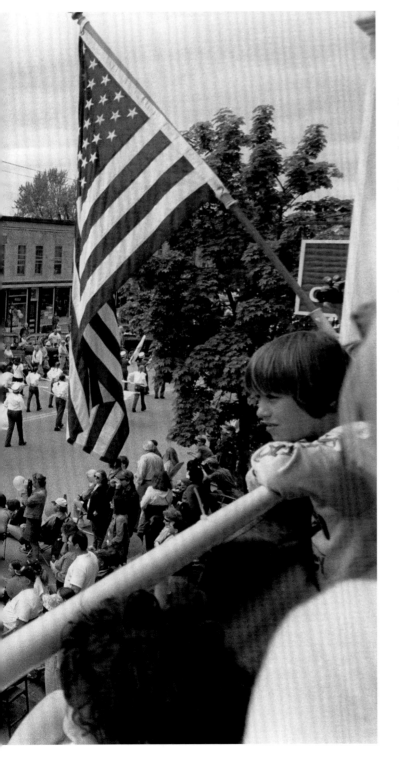

Parades. It doesn't matter the occasion—4th of July, Memorial Day, Old Home Day, or in celebration of milk or maple syrup or whatever — it's an excuse to march down Main Street, honor guards with flags flying, held by proud veterans, bands playing, old cars and trucks and tractors beaming in their new wax jobs, horses impeccably groomed and cows too, floats of various groups throwing candy to the kids on the sidewalk, Shriners topped by fezes looking ridiculously funny crammed into tiny vehicles buzzing about, Boy Scouts, Girl Scouts, 4-H, middle schools, booster groups, pretty women seated in convertibles, clowns, oh don't forget the freshly scrubbed fire engines, red as sin, and the local officials, business boosters and politicians; few know their names unless it is the governor but these folks are grinning for all its worth and waving vigorously. And on the sidewalks, the rest of the town, shoulder to shoulder, clapping, smiling, and shouting hellos to their friends who are in the parade. Everyone's having a good time. This is small town America.

After the parade, and sometimes before, people gather in the town park to picnic, fondle the various crafts sold in tents, have hamburger and hot dogs or a chicken barbecue prepared by the local Rotary, Lions Club, church, or fire department. They sit on the grass or park benches with relatives and friends, listen to local fiddlers and jazz groups and, in the evening, there might be a flowering of fireworks and maybe a street dance. It's a celebration of what is best about living in a small community — hanging out together to affirm they are all members of a proud tribe.

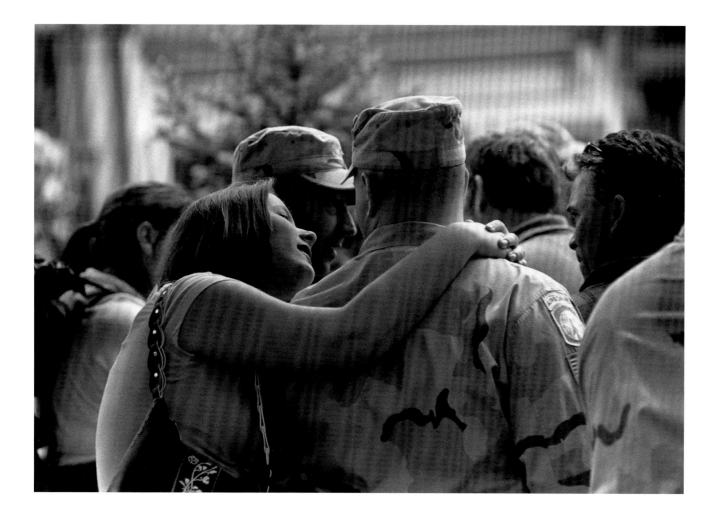

Memorial Day, Vergennes

"The oldest smallest city in Vermont" is how many people describe Vergennes. The city's Memorial Day parade is one of the largest and brightest in the state but there is also grace and solemnity in the services in memory of those who fought — and died — in service of their country. It was particularly pertinent this year. By Tuesday May 31, eleven Vermonters had been killed in Iraq, the highest per-capita rate in the country, and forty had been wounded, more per capita than any state other than Arkansas. That hurts in a small state where people refer to friends as cousins.

The Vergennes American Legion is the perennial sponsor of the Memorial Day ceremonies and they do a poignant job. The services take place on the green next to Main Street; participants and observers gather around the white bandstand, which holds the Vergennes Union High School Band. Many in the crowd are veterans, wearing uniforms with campaign ribbons pinned over their hearts; others wear caps with the name of their branch of service, or of the ship they served on, or indicating that they earned a Purple Heart. There are single women with children, full families, and couples, seated in folding chairs, lying on the grass in blankets, or standing under the trees, where the sun is screened by leaves.

The high school band played the national anthem and the pastor of the Vergennes Congregational Church gave the invocation. The mayor said a few words and two veterans, a man and woman from an older war, laid a wreath on the monument that faces the bandstand. This is as it always is.

Two eighth-graders from the middle school recited "In Flanders Field" and the Gettysburg Address. The words could be heard in the back of the crowd, it was so silent.

A twenty-one-gun salute was fired by soldiers in desert camouflage, standing at the edge of the green next to an American flag held by the honor guard. They were from Battery B of the Vergennes Armory, and all had recently served in Iraq.

Father and son buglers counterpointed each other as they sounded the soothing and haunting Taps, composed in 1862 by Union General Daniel Butterfield after the battle of Gaines Mill, where he lost six hundred men.

The service closed with a benediction from the chaplain of the Vergennes American Legion. It was a touching ceremony and washed clean many of our emotions.

Other towns in the state, those that had lost one of their own in the war, had more bittersweet services.

Let them drink milk! should have been the logo at Enosburg Falls' Vermont Dairy Festival. Almost everyone was sucking on a half-pint. Booth Brothers Dairy gave out free milk that was rBGH free and kids in baby carriages and seniors in wheelchairs were downing the stuff. Milk posters and logos were stuck here and there. Kids were having their photographs taken with milk moustaches (made from watercolor paint). The theme of the festival was "Vermont troops drink milk." Hmmmm . . . not what I drank when I was a soldier. Maj. Gen. Martha Rainville, Vermont adjutant general and leader of the Vermont National Guard, was the Grand Marshall but she didn't lead the parade. Spot, formally known as Harvest Hill Reno Mercy, did, and was given the title of Honorary Grand Marshall. Spot is an Ayrshire cow owned by Anne Burke, whose farm is in Berlin and that's not even in the county. Seems as though the 65,000-plus dairy cows in Franklin County, the largest population of milk cows in the state (yes, more cows than people live in the county) were too busy, or maybe they didn't have the manners of Spot, who is gentle, likes to be petted, pretty, clean as snow, and knows how to march and when and when not to plop.

Is there any other town in the state that would start their parade with the American national anthem sung by a pretty woman and the Canadian national anthem sung in French by a darkly handsome man? Probably.

This festival, held in early July, is a very relaxed and happy affair, and just what is needed for a town suffering the loss of a town block to fire earlier in the year. The fair

is organized by the Lions Club and runs for three evenings and two days. There is a midway, a horse pull, pancake breakfasts, evening country rock shows, a 10,000-meter Milk Run, and a kids Milking contest. Cow Plop Bingo is held outside. You can image what it is. Do you think it could ever be rigged? The promoters say the festival's parade is the biggest in the state but then Vergennes claims the same for their Memorial Parade. Governor Jim Douglas and his wife walked in the parade, while General Rainville sat in a car. There were no tanks in the parade. There were bands and honor guards of course, but the tractor contingent was extra special and a salute to the staying power of Vermont native John Deere.

After the fair most people congregated in the park and feasted on chicken barbecued by the fire department behind the Masonic Hall. Many cooled off while sitting around the tree-shaded fountain; family groups were spread about on the grass, picnicking. Milk cartons were strewn all over the place (the milk was cool and so good it tasted like it was raw). Even Mrs. Vermontica, the state's mascot dairy cow, made an appearance. It was hot in the sun but cooling off in the evening for the fireworks. A perfect summer day.

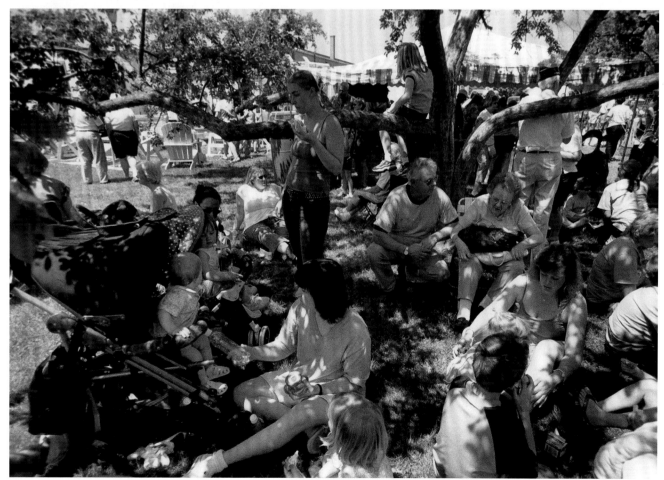

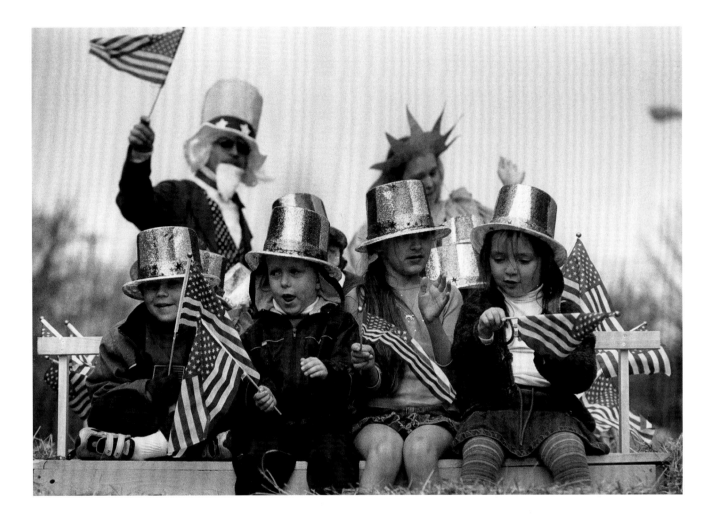

Maple Festival, St. Albans

In celebration of maple sugaring season, of course. Sugaring has usually ended by the time the maple festival opens, which is the third week of April. Late for sugaring, it is the very first of the year's festivals and parades, which town boosters claim is the biggest in Vermont so they are right up there with Vergennes and Enosburg on size bragging. There is a craft show, a 5,000- and 10,000-meter Maple Sap Run, a fiddler's variety show, pancake breakfasts, a carnival, tours to area maple sugar houses, and of course the Maple Festival Parade. It is the only major Vermont parade where marching bands might have to blow their way through a snow squall. Best of show was the team of four workhorses, full of brawn and spirit, barely kept in control by the teamster, as they pranced down Main Street. That's the most excitement downtown St Albans has had since twenty-one Confederate soldiers robbed the banks of $208,000 just before three in the afternoon on October 10, 1864.

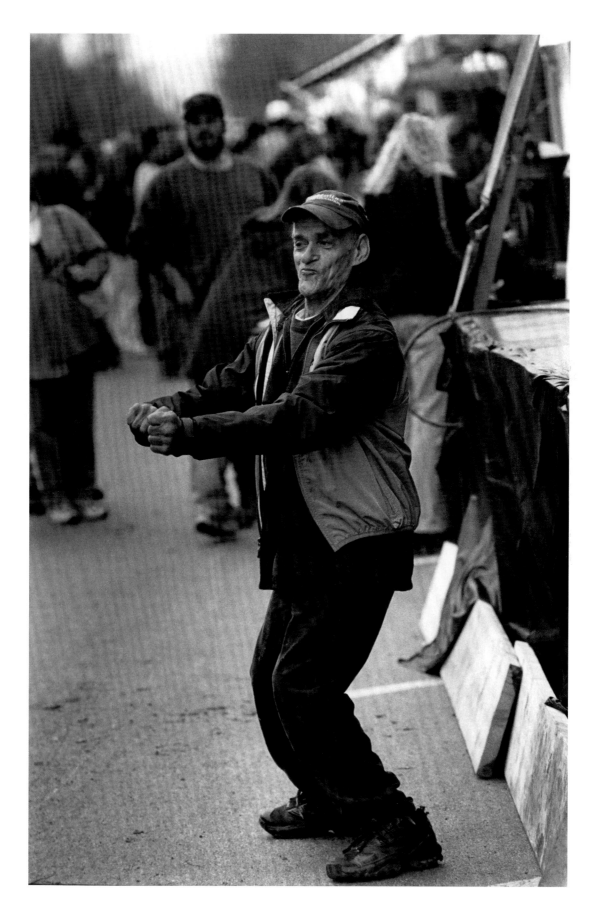

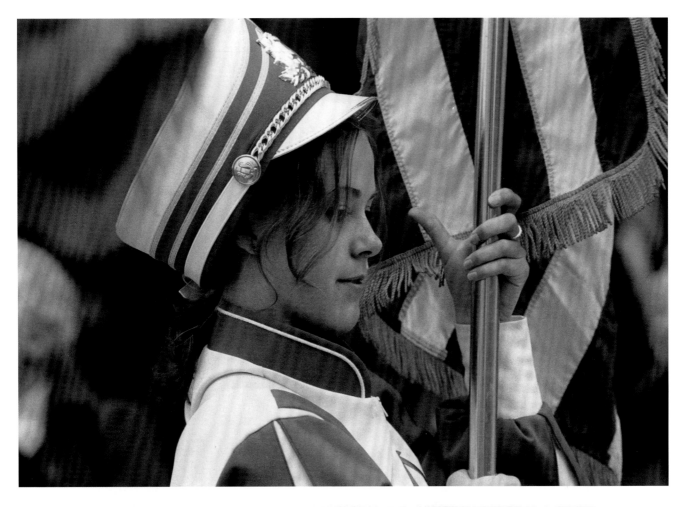

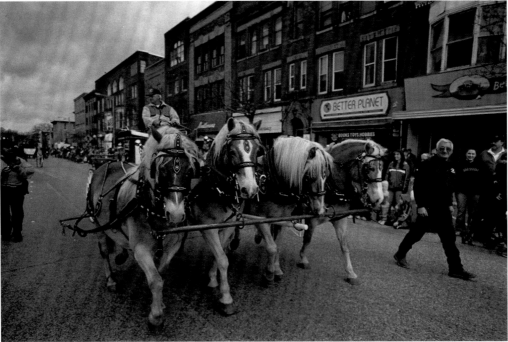

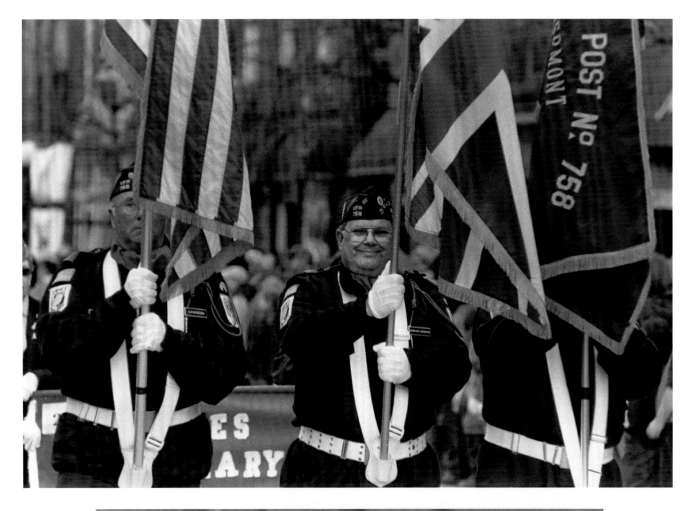

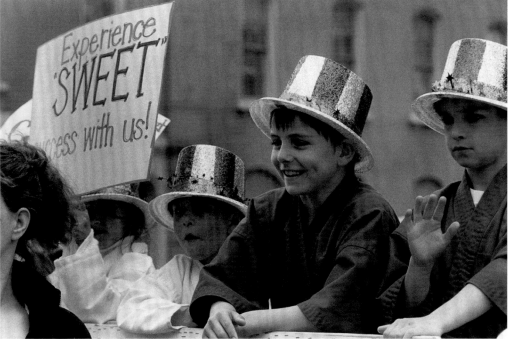

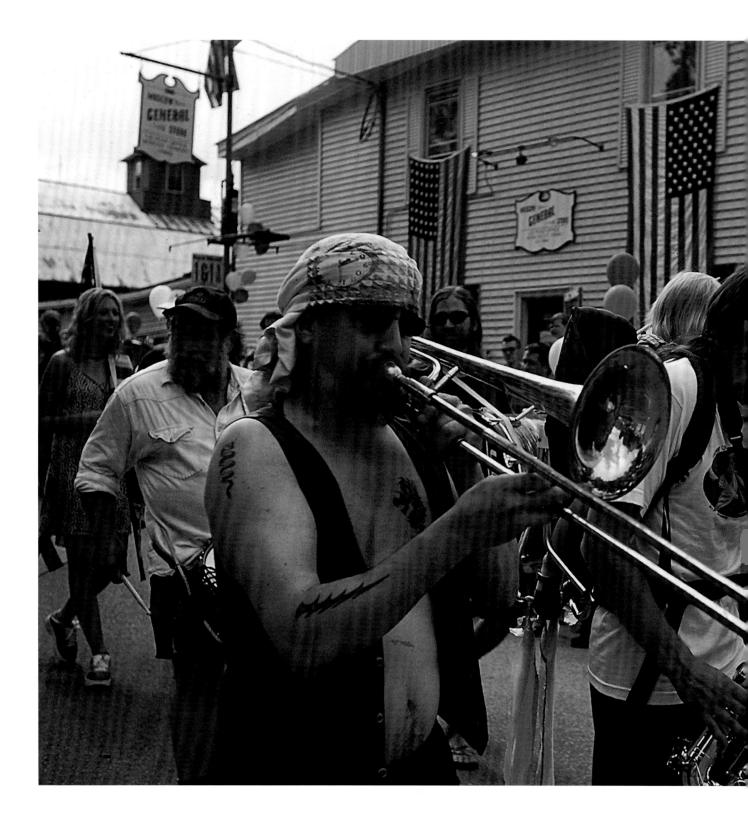

FOURTH OF JULY PARADE, MOSCOW

It all began the night before America's bicentennial birthday in 1976 because the town of Stowe, in which Moscow hides, did not have the gumption to parade. So the residents of Moscow put together a rag-tag band and asked the local radio station to play band music when the parade began at 10 A.M. WDEV did and so traditions are born. The Moscow Marching Band holds blaring radios on their shoulders; the Moscow Women's Chair Team carries folding chairs and every so often stops to sit in them.

The first parade, the shortest in the world they claim, lasted about ten minutes. It was so short they decided to do an about-face and march back. The parade soon became nationally famous and is featured in the book *Vermont People*.

The fair is much larger now. People from Stowe consider it *de rigueur* to view the Moscow Parade and buy a hot dog at the Moscow General Store. Everyone has forgotten that Moscow was at one time on the wrong side of the tracks, so to speak. Celebrities have joined the parade, including Buster the Dog, held by Ken Squire. You have to listen to WDEV to understand why Buster is famous, and it is best if you are local to unravel what some of the paraders are mocking.

At the first parade people who lived in the center of Moscow (a 200-yard strip, no advertising signs) held parties fueled mostly by Bloody Marys. Things were even better after the parade. Not now. Political correctness has seeped into Moscow and there are no more pick-me-ups.

For fifty-five years the United Church of Irasburg, which soars over the corner of the green, has been holding a lawn sale. Well, it is much more than that. The town hall serves as the base and inside there are long tables of homemade pies to sell, and they all do. Food is served, but outside on the green is where the action is. Tents are filled with hand craft events, auctions, games for kids, delicious homemade strawberry shortcake for a mid-morning snack-break, made with strawberries hand-picked by church members, pony rides, live music, and more. On the shaded porch where it is cool, for it's hot out, people sit on the benches and talk with their neighbors. In the afternoon the church holds a barbecue by the side of the church, which is shaded from the sun.

The big surprise of this event is the evening parade. Oh yes, the fire trucks are out, a woman and her son and a dog are dressed as clowns, there are marchers and the Shriners and old cars, but what is that coming up the square and turning past the United Church toward Ray's Market and the town hall? It's a very, very tall Uncle Sam on stilts and behind him huge puppets advocating the rebirth of the Vermont Republic. Flying birds. Somber puppets that appear to take a dim look at what is happening in the world (someone has to), but then there is this rollicking, crazy happy, smiling, dancing band with the most gut-lifting music. Your spirit soars; your heart is giddy. It is the Bread and Puppet gang, led by clan leader Peter Schumann, possibly the world's best stilt walker in addition to being the genius the behind the marriage of huge, Picasso-like puppets to a political agenda. This year Bread and Puppet is appearing in New York City, Boston, and Barcelona. Hardly anyone knows that they come to Irasburg for the fun of it to partake in their neighbor's parade. Fireworks and a street dance follows. ♣

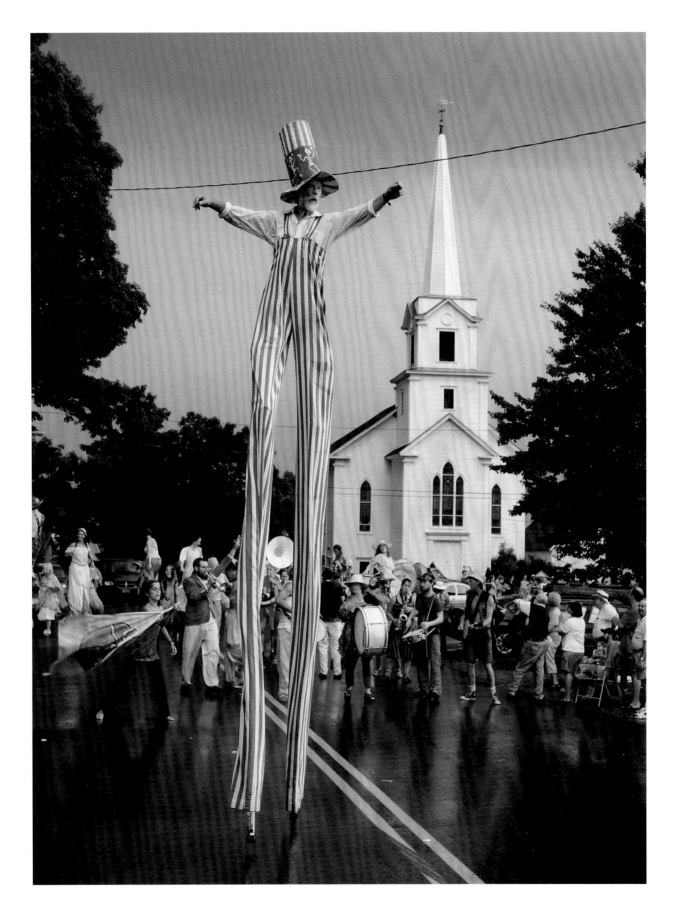

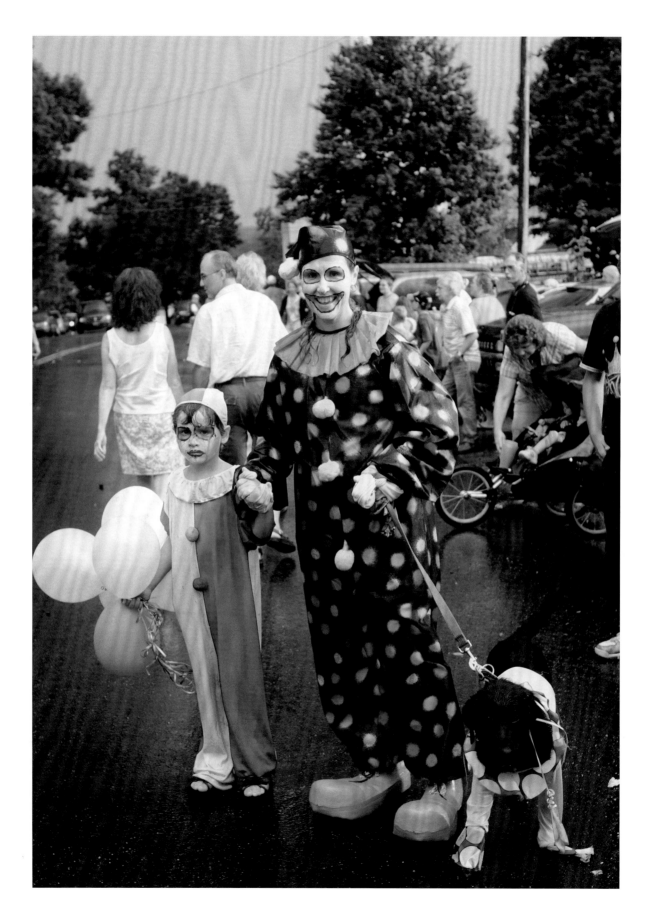

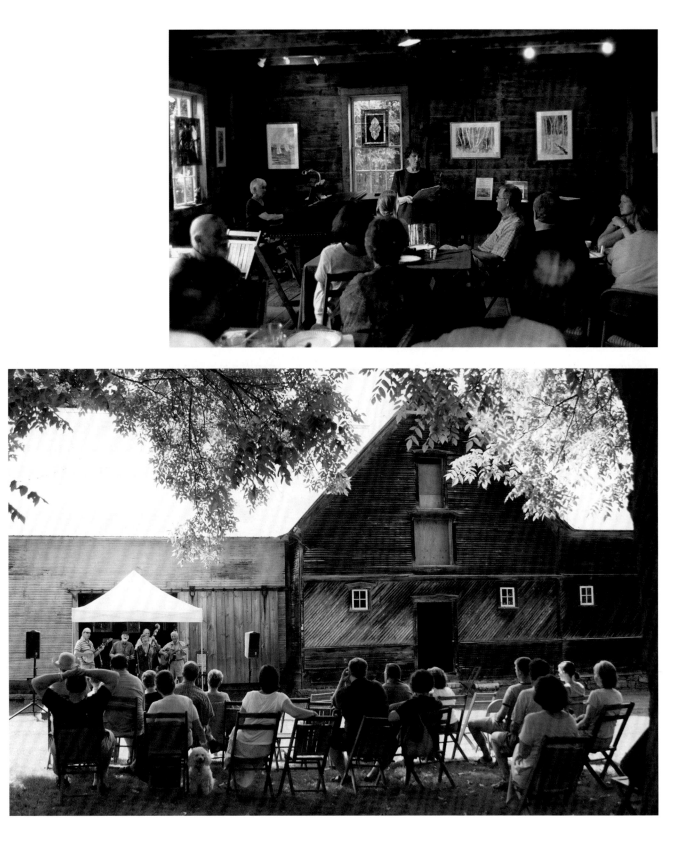

There's something very English about the Fisk Farm on Isle La Motte. Perhaps it is the play of sunshine and shade between the large maples and pines, and the glint of the afternoon sun skimming Lake Champlain, seen through a sieve of leaves. Or maybe it is the serenity of the Victorian-style tea garden set amid flowers, shrubs, and trees and faced by a 200-year-old stone building. It may be the large horse and carriage barn, more Old than New World, recently renovated, with the help of preservation funds. British troops kept their horses in the barn during the War of 1812; hovering over the scuffed hemlock floor is the faint scent of horse sweat and manure. Now guests view paintings, pottery, and crafts displayed in old horse stalls and tack rooms.

Linda Fitch is the owner of the farm, which she took over from her parents. She has, with the help of preservation groups, saved the old Fisk Quarry, part of a 480-million year-old reef, and rejuvenated the horse and carriage barn which now is the focal point of Arts at Fisk Farm, an afternoon of music, art, and tea.

On nice afternoons guests sit under the shade of maples and listen to, depending upon the weekend, a string quartet, folksingers, pianists (there are two pianos in the barn), even jazz and Klezmer music. At intermission guests sip tea and eat cakes in the garden. A fee is charged and donated to the Isle La Motte Preservation Trust, although it is Linda that maintains the farm and the grounds.

"Perhaps it is an unreasonable dream," she said, "and it is not financially viable, but I am passionate about bringing the arts to Fisk Farm, of sharing the spirit of good energy and ambiance that I feel here."

Fisk Farms brings together artists, musicians, performers. and the audience, who come from Canada, New York. and throughout Vermont. In the evening, the barn is converted into a small dining room and performers, volunteers, and sometimes the audience bring a potluck dinner. Instead of saying a prayer, the potluckers hold hands in a circle and sing. During dinner, Linda and Michael Waters, a trained musician who serves as the Fisk Farm's music director, may play a duet. Poetry is read to the accompaniment of piano music, a woman is surprised with a birthday cake, and the yellow Lab does his best to be near the food, pretending to be just lazing about. Like the rest of us. ❧

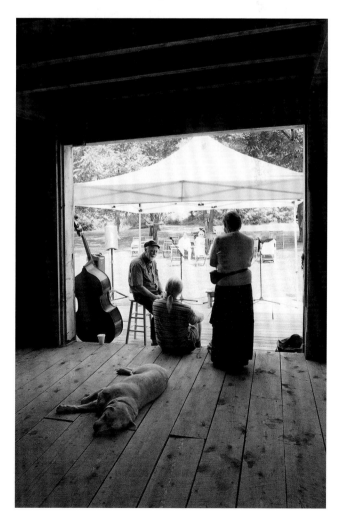

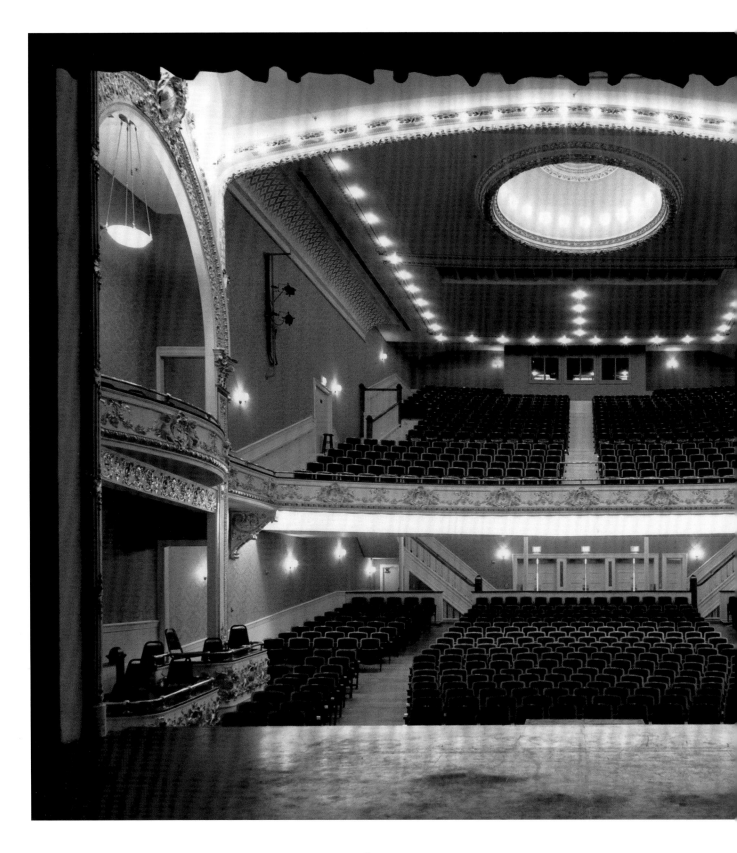

PARAMOUNT THEATRE
Rutland

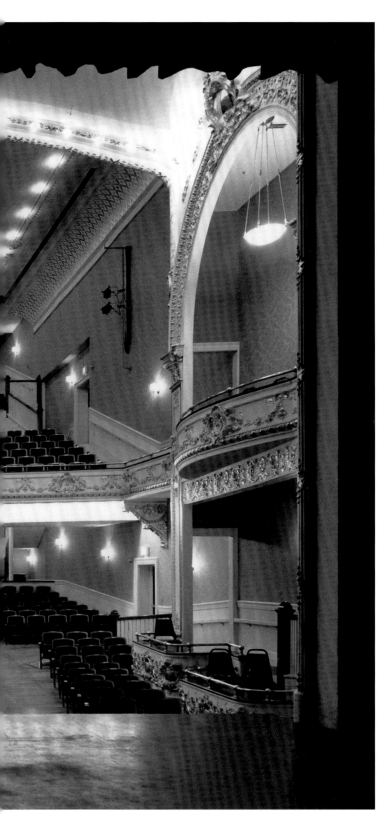

The first impression of the interior of the Paramount Theatre is of delicious, decadent opulence. Rose-colored tapestry covers the sidewalls and velour hangings adorn the boxes. Columns and arches and the decoration around the boxes are shaped in the classical style, all ivory and gold gilt stucco, which also runs along the ceiling, the front of the balcony and into your sense of luxury. There are some very pretty opera houses in Vermont, but nothing like this one. It is reminiscent of the luxuriousness found in the gentlemen houses of Paris before World War II when, for their gala opening, searchlights lanced the sky, the Republican Guard on horseback stood at attention, and royalty and idle rich from around Europe were in attendance.

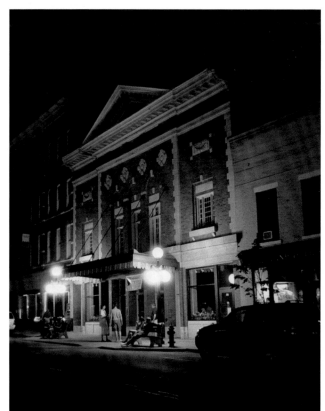

The Paramount, with its gleaming décor, has had three lives. The first began in January of 1914 when the Playhouse, as it was called, opened to a seventeen-year run of minstrel, grand and light opera, and vaudeville. It was reputed to be one of the most elegant small-town theaters in America, and it drew big names in the entertainment world — pint sized Tom Thumb, humorist Will Rogers, actresses Sarah Bernhardt and Ethel Barrymore, the Great Houdini.

In its second incarnation, the theater, now called the Movies, changed from live shows such as *Mutt and Jeff in the Wolly West* and *My Lady's Garter* to blockbuster films including the four-hour *Gone With the Wind* (1939) and *Mrs. Miniver* (1942). The theater's decline came with the onslaught of television and the Movies closed in 1975, degenerating into a decrepit ghost hall.

What is so surprising is that the Paramount, in its present form, is now in better shape than it was when first built, thanks to a stubborn band of Rutlanders that bought the theater and raised $3.8 million to bring it back to life. Arlo Guthrie and the Vermont State Symphony officially opened the theater to a sold-out house on March 18, 2002.

The theater's schedule is tailor-made to gather an eclectic group of performers and audiences. There is a Playhouse Series, which is for dance, comedy, music, and children's shows; a Broadway Series, for touring stage shows; and Education is Paramount, which extends the local school curriculum to the stage.

But what is so electric about the Paramount is whom it attracts. Of anyone, Rip Jackson has made the best use of the Paramount as a gathering place for Rutland. He is a transplant to Vermont, a Minister of Music at the Grace Congregational Church of Christ, with 850 members. Rip is a minister "only in the spiritual sense, in that music connects us together, elevates us." He is a singer, keyboard player, director, choreographer, and conductor who specializes in Baroque repertoire but has recently made his reputation by producing musicals that are performed in the Paramount. They glitter with professionalism, none so much as a recent production of *West Side Story*.

For an amateur group to take on this musical, with its intricate choreography and Leonard Bernstein's incredible fusion of jazz, Broadway, and classical music, calls for folly, courage, or ego. Rip and his group pulled it off.

"We had a cast of over fifty and half were people who are in the church choir. We practiced for five weeks. All the musicians were from the region. Although the actors were volunteers, we paid the musicians. They only had three days to put the show together; the actors rehearsed for the five weeks."

The show was performed for three days in July 2005 and it broke attendance records for the reincarnated theater — thirty-two hundred people bought tickets, which included a standing room only matinee on a sweltering afternoon and the audience knew the theater had no air conditioning. It took a lot of Rutland chutzpah to put on such a professional production of *West Side Story* and it worked. The Paramount, and people like Rip Jackson, are gathering together not only the town's residents and talents but shaping a new personality for Rutland. ❧

"Arts and the theater bring together
people of different backgrounds and
human spirit. Put them in a play that
has struggle and represents prejudice,
such as 'West Side Story,' and we all
learn from it. Our plays are bringing
together the community."

RIP JACKSON
Director and Minister of Music,
Grace Congregational Church, Rutland

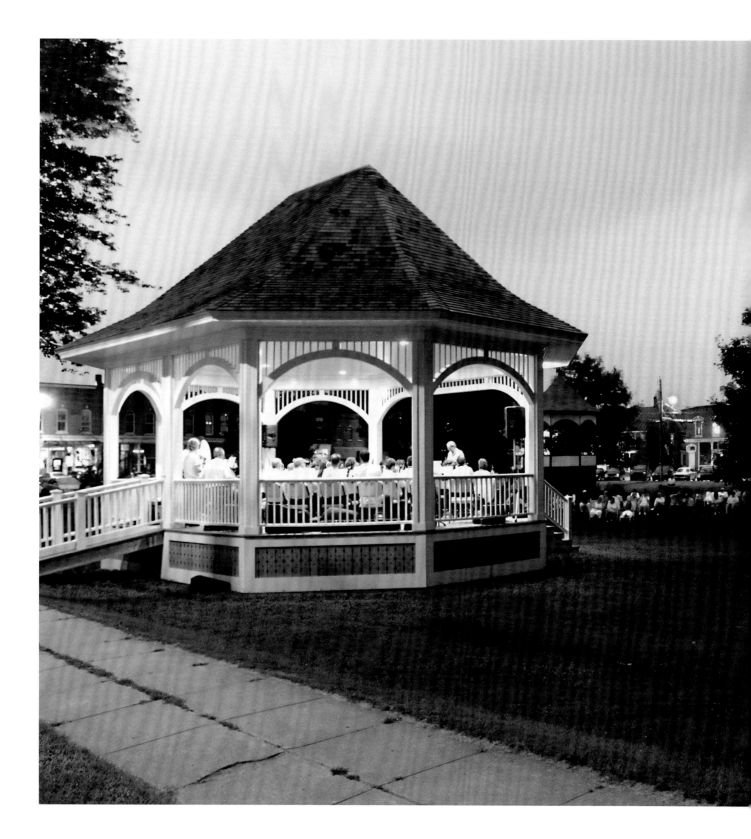

SOUTH ROYALTON BANDSTAND
South Royalton

Summertime. The evening light is soft and sweet as it settles over South Royalton. Although the town is in shade, sunlight gilds the bandstand. People are slowly gathering, carrying chairs, and setting them up in a semicircle, just in front of a Civil War–era canon aimed at the bandstand. Some bring blankets, picnics, newspapers. This happens every Thursday night and has been going on longer than we have been alive. It is the evening band concert.

South Royalton's town band is special, because Dick Ellis is the conductor, and has been for the past fifty-nine years. He is Vermont's music man, teaching thousands of schoolchildren to play instruments and conducting more concerts than he can remember. He also founded Ellis Music, a company that rents out over four thousand instruments to schoolchildren in Vermont and New Hampshire.

Town bands are an integral part of small town social life. For more than a century every town worth a toot had a town hall and a band, the roots of which go back to the military bands of the eighteenth and nineteenth centuries. According to early records, Strafford had the first Vermont band; they supported one in 1811. Rutland is reported to have the oldest municipal band in America. Town bands not only played at important holidays but, during the Civil War and World War I, marched to the train depot with the troops and sometimes, in the Civil War, accompanied the soldiers to the battlefield.

"The biggest value of a band is that it gathers people together. It gets them out to visit with other people and enjoy music," says Ellis.

The South Royalton Band plays medleys of Broadway hits from *South Pacific, Oklahoma, The Sound of Music,* and of course, *The Music Man.* They play familiar marches and sometimes jazz. The music taps into memories.

"Bands bring families together," said Ellis. "I would teach a student to play an instrument and then, after she started a family, she would drop out. Later she would bring her children to our concerts and I would say, 'Why don't you get out the old trombone and play with us?' and she would. And then her children would learn to play an instrument and now I have fathers and sons and mothers and daughters playing in our band. Three of my children are also members.

"Music makes students better scholars. They learn to read music and use their eyes and ears. It forces coordination of the fingers, tongue, and breath. It teaches them to think and work with a group. And remember, a basketball team has only 5 players but a band can have 150."

"You know, John Phillip Sousa composed waltzes and operas, but he gained his reputation when the beat was changed to a march. It's been said that he played for the first time his most famous composition, 'Stars and Stripes Forever,' in Vermont."

The evening fades to night. Fireflies are flashing their erratic dance. A couple of June bugs attack a street lamp. The ceiling lights of the Richard Ellis Bandstand glow as the music flows over the green. It is a new bandstand, paid for by local businesses and individual contributors, large enough to hold fifty or so players, and of course is named for South Royalton's most cherished resident. The band plays "Stars and Stripes Forever" and the national anthem. People stand, their hands over their hearts. A half hour after the concert the green is empty and lights in the houses and Main Street businesses are extinguished. The band music that hovered over the green fades away to a memory. All is quiet. ♣

The South Royalton Band plays in the House Chamber at the State Capitol Building in Montpelier as part of the Farmers' Night Concert Series. The band is a nonprofit organization that entertains, educates and perpetuates musical band culture.

Vermont had not seen anything like it, and never will again. On the shore of Lake Champlain, William Seward and Lila Vanderbilt Webb created, in 1886, a fourteen-hundred-acre model agricultural farm that is reminiscent of the estates Turgenev grew up on but with Norman architecture replacing the Russian. They hired New York City's Central Park planner Frederick Law Olmsted to do the landscaping. They planted thirty thousand trees. The scale — the sense of power — in the structures so well placed on the rolling fields displays a sense of elegant grandeur lost on the "McMansions" of today.

Amazingly, Shelburne Farms has never been subdivided. A National Historical Landmark, the property is still intact and is now an educational nonprofit farm run by descendants of the same Webb family that initially dreamed of its beauty and purpose. On the property is the old estate house (which is now an inn), a dairy farm and cheese making facilities, and a coach house of indescribable charm with its interior courtyard. There are woodlands, pastures, and mowings.

One of the least known, and most effective, of Shelburne Farms' environmental programs is the

Children's Farmyard, which is housed in a small section of the Majestic Farm Barn. On any given day, there are scores of kids whose excitement is infectious as they squeal and squirm, touching and kissing the animals. What do they learn?

"Did you know that brown milk does not come from brown cows?"

"Eggs are warm when they're laid."

"A cow has three stomachs and four teats and you can squeeze white milk out of them. Go on, try it."

"These kisses are scratchy!"

A lot of thought went into the structure of the educational programs at Shelburne Farms and that is why some 120,000 people visit every year — school trip kids, parents and their young. Yes, even the adults can't resist petting and holding the animals. ❧

Horses like to be rubbed. Vegetables do not grow wrapped in
cellophane packages, and strawberries taste best when picked off
the runner. Rub fresh basil between your fingers. Did you ever
smell such a fragrance? Yes, picking weeds is drudgery. There
are bucks and does and kids and rams and ewes and lambs and
don't get them confused. Every farm animal has a purpose
and so do human beings. Animals help you smile.

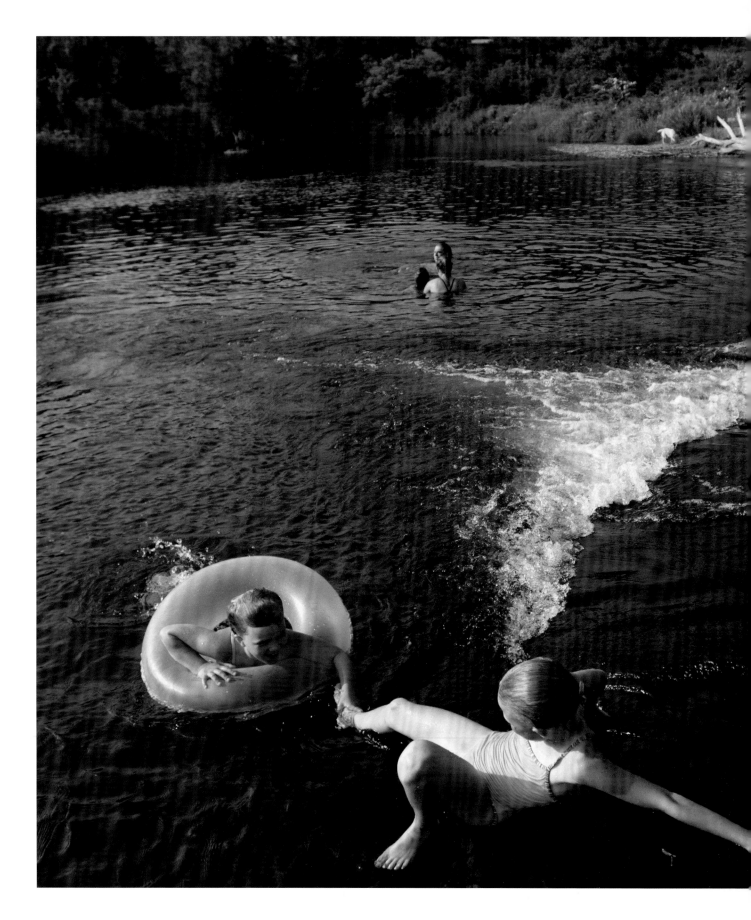

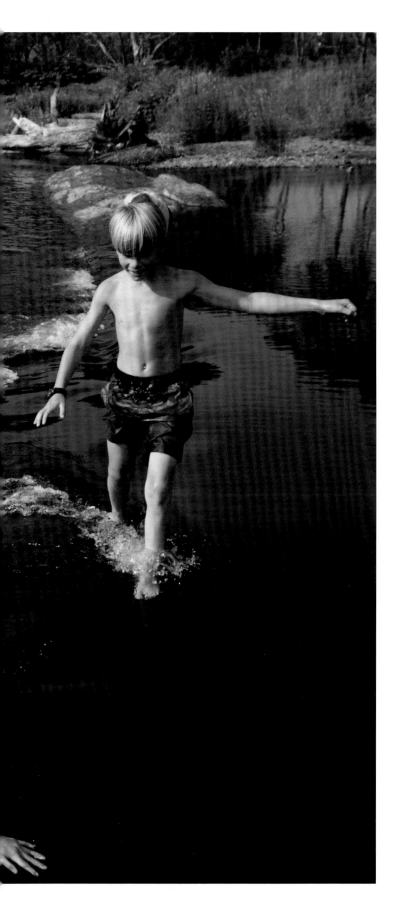

SWIMMING HOLES
Undisclosed Lamoille County Locations

There's a Web site that lists 72 swimming holes throughout Vermont. There is also a book on the subject. These are travesties to the integrity of Vermonters' secret swimming spots. If you want to find a swimming hole, do your own snooping.

Of course, some of them are well known or near a road so you can pull off and dive in, and many do, without exchanging shorts for bathing suits. But the others are hidden in the woods and reached after a short hike; the sun lights them for only a few hours a day. Waterfalls cascade over the rocks, with water bubbling and flowing into a deep emerald pool. There are invariably cliffs to jump from. These wooded swimming holes are beautiful and true Vermont gems.

The best are found on small streams whose roots flow upward to the summit of the Green Mountains. Some of the finest are located in Lamoille County, under the shadow of Mt. Mansfield and the Sterling Range. There are many, many of these swimming holes, and they have been cool sanctuaries where Vermonters have congregated for centuries. The pleasures are the beauty, the thrill of the cliff jump, that absolute delight of diving into stinging cold, glass-clear water, then after, the refreshing warmth of sunlight.

I'm not telling you where these swimming holes are, although those pictured here are well known. I won't tell you about others in this county. They remain a secret. These are the most private, most beautiful of gathering spots. They refresh body and soul. ❧

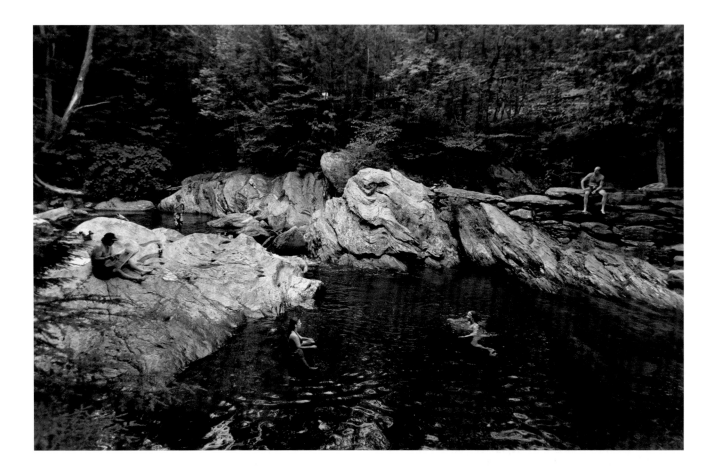

Mountain streams follow a path of least resistance, flowing around
immovable, mammoth boulders and cascading through gorges. Here,
before they reach the valley and become rivers, they sometimes rest
and form deep clear pools we know as swimming holes.

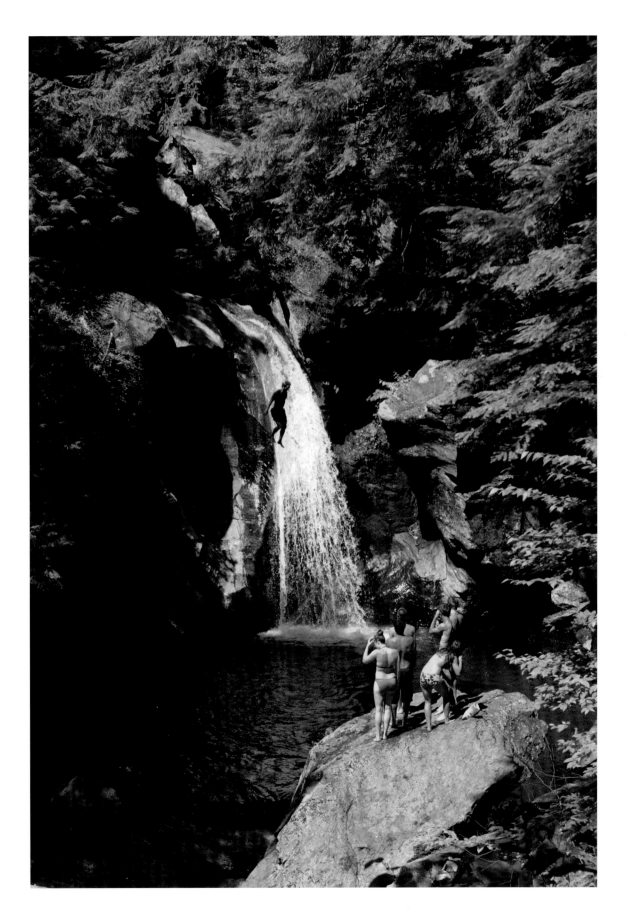

WORLD'S FAIR
Tunbridge

It took a lot of moxie, in 1867, for the locals to name it the Tunbridge World's Fair, but something a bit stronger gave this country fair its mythic stature. Up until the 1970s the short midway was renowned for its booze, brawls, and girlie shows. The deputy sheriffs walked in pairs; with their Stetsons they stood six and a half feet tall, clones of pro ball players, who humored the pint-sized men who wanted to fight them. It was the bigger, pugnacious drunks that had their cages rattled.

That was its reputation, but now Tunbridge, in this era of political correctness, is just an old-fashioned, ungentrified agricultural fair where the best time is had by the 4-Hers who show their heifers, oxen, rabbits, and chickens, and spark up four-day romances with each other, and the young nuts-and-bolts racers who battle to perdition on Sunday afternoons in the Demolition Derby. There are tractor, pony, ox, and horse pulls, trotting races, horsemanship events, contra dancing, and too many blooming onions and maple-syruped fried dough .

Listen what farmer Anne Burke has to say about the fair, and she goes to them all.

"The Tunbridge Fair. It's premium, and if you haven't been to Tunbridge, you haven't lived yet. Others say that you can't get in without holding someone else's wife with one hand and a pint in the other but I wouldn't know about that.

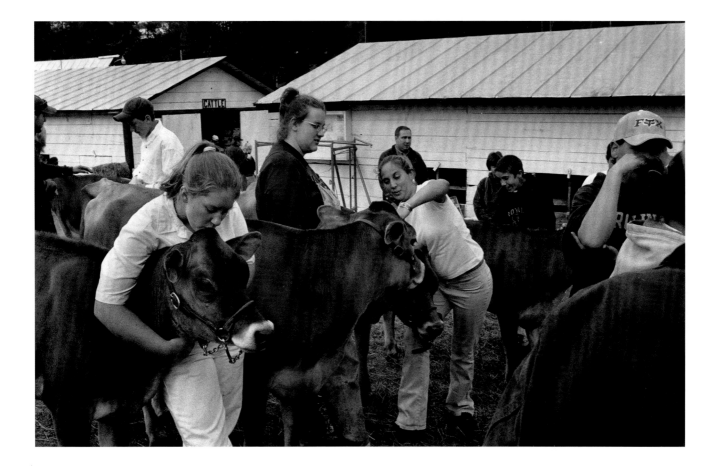

"I been bringing cows to the fair since 1968. I met my husband in the dance hall we called Dreamland. We just celebrated our forty-forth anniversary.

"We bring our prize Ayrshires and for two years we won Supreme Champion of the Fair. Now my grandson Jesse, who is eleven, won Junior Champion and came home with $68 in premiums.

"We used to sleep overhead in the cattle barns and in some years we pulled out bales of hay and slept with the cows. Well, that's gone, along with the girlie shows. Now we sleep in campers and the girlie shows, I don't know where they went.

"Oh, it's a celebration! I like to see the big pumpkins and veggies, and eat corn on the cob, and meet people I went to school with and catch up with farmers you see once a year. Oh yeah, I sure like the tractor pull! Got eight of them myself. Tunbridge is the last fair of the year."

Sometimes on those crisp fall nights you can find fiddling and impromptu barefoot dancing on the fresh-cut grass, moist with dew. There's a snap in the air and at this spot and time Vermont is the best place in the world to live. 🍀

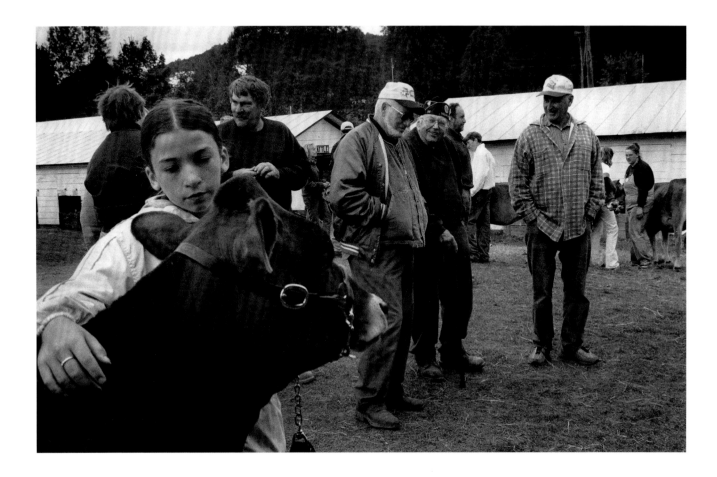

Some fairs seem to have a barrier between the agriculture section and the midway. Not so at Tunbridge. All fair goers are invited to wander through the long sheds where farmers bed their prize livestock, and that's the best part of the fair.

It doesn't matter what fair, the Demolition Derby packs them in. It is usually held on the last day, a growling, snarling, exhaust-choked event that often takes place in mud a foot deep. It answers a need for people to wreck havoc for a prize and is the most democratic and least expensive of all automotive racing. Where else can you build something so you can destroy it, just to rebuild it again?

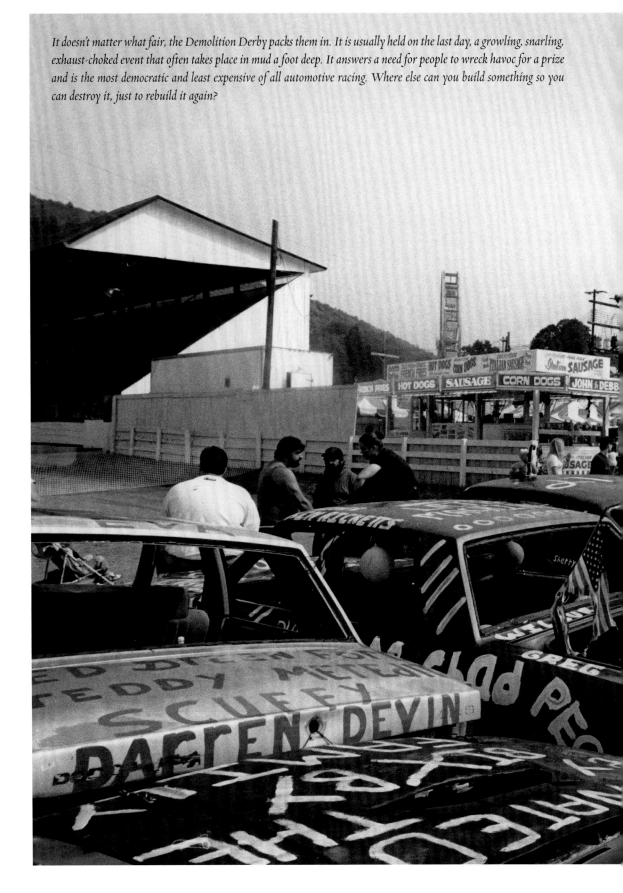

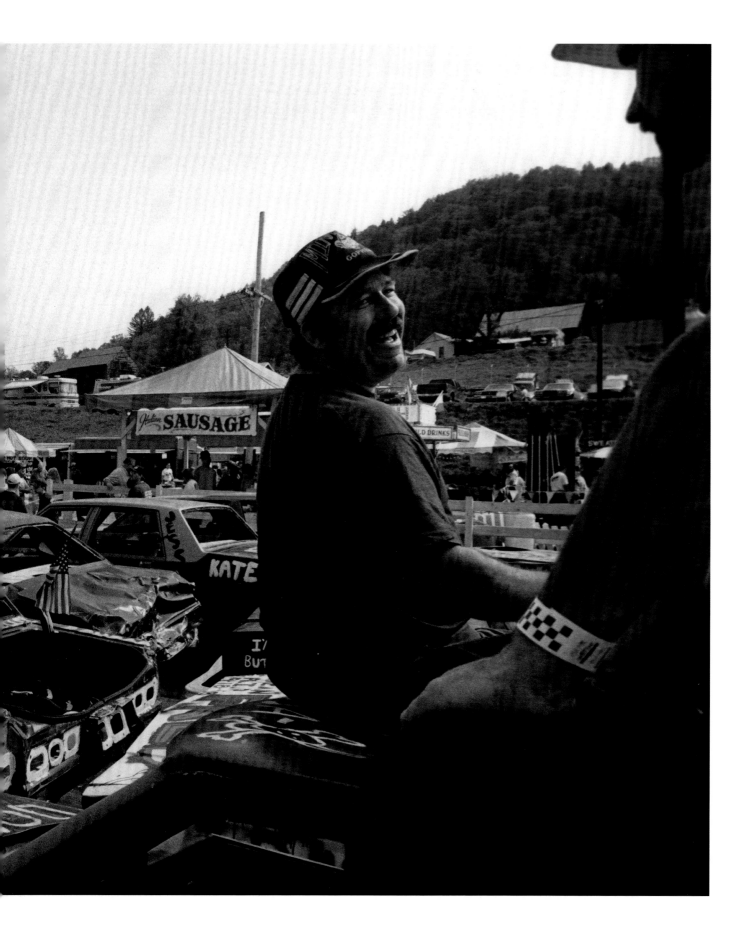

BELLOWS FALLS
Bellows Falls

I just returned from Bellows Falls, my last assignment, and I'm buttoning up this book. It's been a frenzied six months. I drove five thousand miles and visited every county in Vermont. I took 247 number rolls of film (I'm old-fashioned; I also shot some digital, but am not comfortable with it) and there is a file drawer jammed with research.

I originally thought the Preservation Trust, which supported this book, preserved old buildings, and they do. When I, and others who live in Waterbury, were opposing a big-box development on Route 100, the beginning of sprawl in our town, the Preservation Trust supported us financially (unfortunately, we didn't prevail).

The Trust preserves old buildings in our towns and cities, because they are a focus point for our communities. The Trust doesn't like sprawl, because it weakens the downtown, the heart of a community; big-box stores suck the blood out of them.

Vermont towns and cities are a collection of gathering places; people congregate downtown for work, shopping, culture, and entertainment. They attend meetings, seminars, and classes. They go to restaurants and bars and the library. Sometimes they go to jail.

To get a feel for a place I'm about to photograph, I like to visit the local bar and chat up the bartender, and then drive the side streets. This is a good way to quickly size up a town. I have driven past beautiful old buildings that need to be restored, empty brick factories, elegant Victorian homes, and some pretty sorry apartment buildings, the type visited by Detective Gunther. My recurring thought as I traveled the state was, considering the cost of a hillside lot with a view, there are great real-estate bargains in Vermont downtowns.

Bellows Falls has been blessed by happenstances. Interstate 91 streaks pass it, carrying most of the heavy traffic. It doesn't have the problems Woodstock, Stowe, and Manchester have — state highways overwhelming their downtowns with truck traffic. Invasive sprawl has shied away from Bellows Falls, taking hold to the north in Springfield, to the south in Brattleboro, and across the Connecticut River in New Hampshire.

When the factories closed, very, very few businesses moved to town, and Bellows Falls remained fallow. There was little change, leaving the downtown intact. Local people own the stores and work for themselves. A movie theater is in the town office building and run by the town. Tickets are $3.50 ticket and the popcorn is practically free.

Nick's is an old time bar — dark, quiet with pool tables in the back and four beers on tap. There is a pressed-tin ceiling that is more than sixty years old. The small barbershop also has a pressed-tin ceiling from that era, and stuffed hunting trophies are on the wall. It too has the smell of another time.

Yet there is change. Fort Apache, a music agency, moved up from Boston. They are making Bellows Falls a gathering place for musicians, and renovated the lobby of the old Windham Hotel, where traveling folk, jazz, rock musicians perform. Sometimes Fort Apache's musician play on the local tourist train, the Green Mountain Flyer. And there is now an annual Roots on the River music festival. There is a new gallery block for young artists. The galleries are downstairs; their apartments are above. Near the post office (it was not moved out of town as it has been in Manchester and Waterbury) is

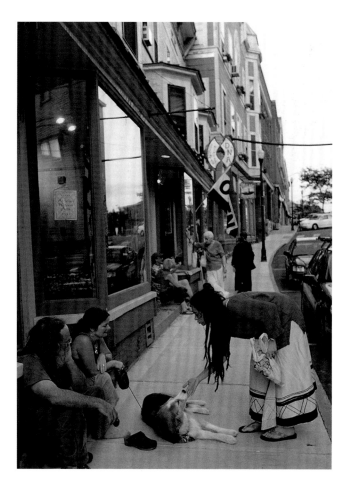

that's in a big city or in the country but never a suburb. My town of Waterbury is becoming a suburb. My friends and I, when we discuss the problems of Vermont — gentrification, crowded roads, high taxes, and the numbness of January — think of moving.

"Where?" we ask each other.

And, after discussing our favorite places to move — Montana, New Mexico, Paris, Brooklyn — we say,

"Well . . . maybe Vermont is okay. We just have to make the best of it. "

Then we talk about the problems of traffic, and the crunch of oil and gas, and we talk about ridiculous real-estate prices and high taxes and the affluent newcomers and what Vermont towns we would like to live in. We think of bicycle paths, and rivers and lakes and bars and restaurants and most of all a lively community. And we think of our old-age alternatives—to live in a town in Vermont or some retirement community in Florida?

We think we'll stay. ❧

another gallery, Spheris, whose parent gallery is in the trendy Chelsea art district of New York. They represent local artists, but their main business is selling to corporations around the country. They're Internet dependent, without it cash flow would be a problem.

An electrician I talked to, as he rewired Miss Bellows Falls Diner, loves the idea of small-town living.

"We've been bypassed and it suits me fine. My kids walk to school; I walk to work. We walk downtown for our shopping. It's quiet and friendly. I can't think of any other place else I would like to live."

Well, there are a few problems. There is no grocery store, although recent renovations have created space for one. There is a hotel, but it is closed and very few motels are gathered around this town.

There are two settings in which I like to live, and

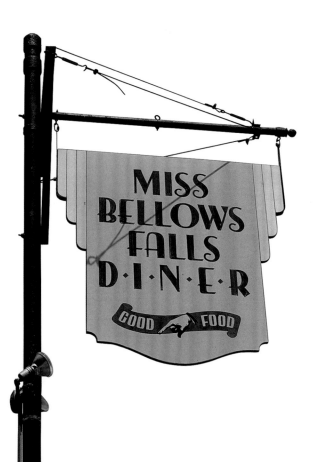

In *Bowling Alone: The Collapse and Revival of American Community*, Robert Putnam carefully details a thirty year nationwide decline in social institutions — the places where people get together. Putnam's data was overwhelming, persuasive, and frightening. While we at the Preservation Trust of Vermont don't have the detailed data to refute his analysis, in the course of our work around the state we have collected an enormous amount of anecdotal information and experiences that say Vermont has escaped the national trend.

This book offers further evidence. Yet we take Vermont's gathering places for granted at our peril. None of them will survive without constant attention and stewardship. Many of them are fragile, and some face major threats.

Vermont's village storekeepers face some of the same difficulties as dairy farmers. Even modest debt can sink these enterprises. Long hours with minimal financial return take a big toll. A lifestyle that requires everyday commitment can be hard to sustain year after year. The best of these stores provides a wide range of goods and services as they as fill the role of community center. If a village store goes out of business even close neighbors can go weeks or months without meeting.

Downtowns provide the same opportunities for community interaction. The best downtowns combine a variety of uses that serve the entire community: retail shops, restaurants, town hall, post office, commercial and government offices, schools, performing and visual arts organizations, movie theaters, religious buildings, libraries, and housing for all income levels. Unfortunately, many downtowns are vulnerable to losing these institutions — some already have. One of the biggest challenges they face is from the big-box stores. People need basic goods at good prices, but when these stores are built on the outskirts of town, downtowns suffer and so does the sense of community. Let's encourage building smaller stores, in our downtowns.

Some communities have seen an incremental loss of gathering places. First the town offices move to the outskirts, then historic schools are abandoned for new schools outside of the center; the post office follows. As a result, the village store loses the shopper traffic and the storekeeper struggles to stay in business. Over time, the heart of the community disappears.

The stewardship of these gathering places and activities is an enormous task, requiring many volunteers. Consider how many community suppers happen across Vermont each year, and the number of volunteers are required to make them happen. Thousands help to maintain churches, community halls, farmer's markets, libraries. Community groups work hard to save historic buildings so they can offer a gathering place. Each activity and each building requires careful stewardship; we're lucky — and grateful — that people care enough to maintain and provide financial support for each of them. Every year, new volunteers and contributors are needed.

Solutions exist for these challenges, but they require passion, technical support, encouragement, and financial resources. We need the will and courage to say No when Yes would undermine the vitality of our communities. With continuing support from our donors and involvement in a variety of partnerships, the Preservation Trust of Vermont is committed to spending the next twenty-five years protecting the character of Vermont and strengthening the vitality of our communities. Please understand this is not about "pickling" Vermont, it's about finding smart ways to grow and building on the essential qualities of the state. It's about being good stewards of the Vermont we cherish.

We hope you will be a part of the work that is ahead.

PAUL BRUHN
Executive Director
Preservation Trust of Vermont